# FOOD

## IN THE LOUVRE

## MUSÉE DU LOUVRE

Henri Loyrette
President-Director

Didier Selles
Chief Executive Director

Catherine Sueur
Deputy Executive Director

Hervé Barbaret
Deputy Executive Director

Juliette Armand
Direction of Cultural Development

## PUBLICATIONS

**Musée du Louvre**

Violaine Bouvet-Lanselle
Head of Publications
Series Editor

Camille Sourisse
Editorial Coordination

Fanny Meurisse
Photo Research

**Flammarion**

Sophy Thompson
Director, Illustrated Books

Translated from the French
by David Radzinowicz
Design: Isabelle Ducat
Copyediting: Penelope Isaac
Proofreading: Marc Feustel
Typesetting: Gravemaker+Scott
Color Separation: Reproscan, Italy
Printed in Malaysia by Tien Wah Press

## AUTHORS

**Paul Bocuse** has been awarded three Michelin stars continuously since 1965 and is regarded as one of the greatest French chefs in the world. His fame has led him to meet a number of equally famous artists throughout his life; including César and Arman. He is the author of many books, including *Bocuse in Your Kitchen* (2008) and *Regional French Cooking* (1992), and was featured in *Great French Chefs* (2003)all published with Flammarion.

**Yves Pinard** is head chef at the Grand Louvre restaurant, situated below the I. M. Pei Pyramid at the Louvre. He is internationally renowned for his historically-themed dinners, inspired by recipes and paintings from past eras. He is a member of l'Académie Culinaire de France and author of several books on the relationship between art and food, such as *Toulouse Lautre: Les Plaisirs d'un gourmand* (editions Scala, 1993) and *Cuisine et peinture au Louvre* and *Cuisine et peinture au musée d'Orsay*.

*Editor's Note:* All measurements of works are given in height by width unless otherwise indicated.

Distributed in North America by Rizzoli International Publications, Inc.

Simultaneously published in French as *Plaisirs de la table*
© Musée du Louvre, Paris, 2009
© ESFP, Paris, 2009

English-language edition
© Musée du Louvre, Paris, 2009
© ESFP, Paris, 2009

09 10 11  3 2 1

Dépôt legal: 10/2009
Louvre ISBN: 978-2-35031-246-0
Flammarion ISBN: 978-2-0812-2821-4

www.louvre.fr
www.editions.flammarion.com

# FOOD
## IN THE LOUVRE

**PAUL BOCUSE**
**YVES PINARD**

MUSÉE DU LOUVRE ÉDITIONS | Flammarion

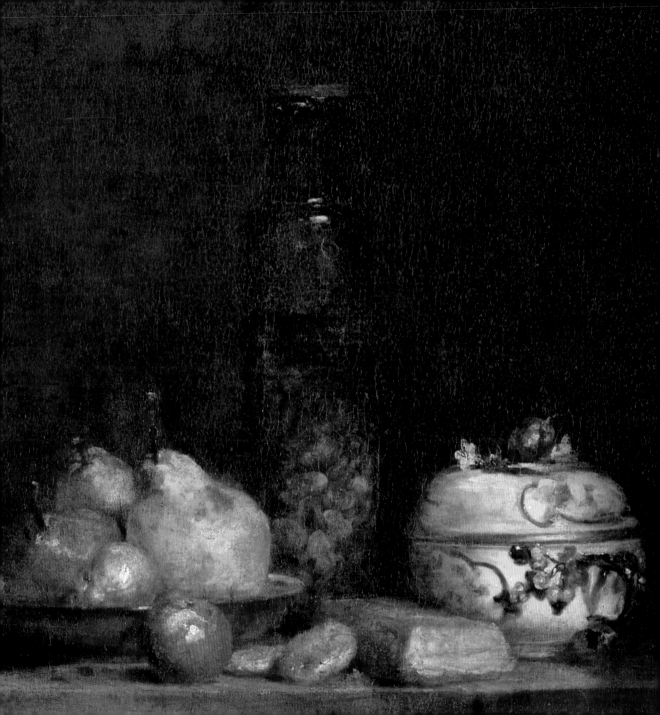

# PREFACE
## by **Paul Bocuse**

At the abbey of Collonges, I have had a small kitchen-cum-museum installed in honor of my late grandmother. At the very place where she used to cook in 1924, the entire original decor has been reinstated, complete with the fireplace as backdrop and the farmhouse table as centerpiece. There's a convincing fake bass *en croûte* ready to gratify any imaginary guests, together with a cake concoction in choux pastry looking fit enough to … eat. A wax figure dressed up as a cook surveys the scene, like those painters frozen for all eternity in reconstructed studios, working away amid all the dried-out palettes and bristling brushes.

This nod to art amuses me because, though I am neither a specialist in art history nor much of a museum-goer, I do enjoy painting and art in general. The present volume seems to me to be ideally suited to people such as myself—those who traipse through museums in a rather haphazard fashion, only coming to a halt every now and again in front of some picture they find especially attractive or intriguing. Yves Pinard's commentary casts an enthralling light on the works reproduced and he has even thrown in a few mouthwatering classic recipes.

As a preamble, and with no absolutely claim to artistic insight, I would like to share my personal reading of this account of *Food in the Louvre*, the views of a chef on examples of visual art that depict various subjects from what is my everyday working life.

The current fashion is to treat chefs as artists in the proper sense of the word and to see every dish as a work of art. This definition sounds wholly alien to me. If I feel close to painters and sculptors, it is only in so far as they are craftsmen like me. Whenever I enter an artist's studio, I am forcibly struck by all the "apparatuses" an artwork requires to come into being—that is, by the canvases, the palettes, paints, and brushes in all sizes, by the clay, stone, plaster, or scrap-metal. For me, these are like kitchen utensils! For me too, *this* is the stuff of art—an art born from flesh, from matter, from perspiration, before it is finally embodied, untouchable, and eternal (or at least for as long as it survives). Up to a certain point, then, one can say that art and cuisine are pretty much alike: they both require the handling of matter; they both require attention to form and proportion—the correct dose of seasoning for one, of harmonious volumes for the other—and both are designed to regale the eye. The comparison falls apart, though, once the artist puts down his brush and the cook serves his dish. An artwork is not intended to be consumed—but a meal is.

But what happens when a painter decides to take the pleasures of the table as his subject? He manages something that every cook has, at one time or another, dreamt of being able to do: that is to capture and preserve our transitory efforts forever. For each time we chefs compose some dish, we have to start afresh; every meal we produce has to be perfect and unvarying. We cook lobster for eight minutes, slice the truffles evenly, place the drops of *sauce andalouse* quickly and neatly around the edge of the plate, dress a fillet of mullet with a second skin of scales … made of potato. And all the while we know that, a matter of minutes later, the whole thing will be reduced to a few scraps that have to be promptly cleared away. The painter, though, can testify to our art (I dare to write the word) and, thanks to him, we can earn a scintilla of immortality on canvas.

In my restaurant in Collonges I have surrounded myself with a series of works on kitchen and cookery themes by artists as renowned as Red Grooms, Lennart Jirlow, Jean-Olivier Hucleux, Raoul Dufy, Jean-Michel Folon, Patrice Flori, Jean Couty, Daniel Druet, and Roger Muhl. I have a particular fondness for the last named, a great artist and a dear friend who transforms light as one kneads a smooth, warm dough. I also cherish

many of these works because they remind me of the time my father used to run the business, as do the pictures by Réty that adorn several walls in the dining room. Their creator, a priest known as the Curé Réty, was a striking figure, forever clad in the blue hood he had worn as a captain in the Chasseurs Alpins during the 1914 War and shod in lace-up military boots and puttees. He paid for his meals in pictures, unsophisticated works that imitate nature, sumptuous views of the Beaujolais or of the fermentation vats at the Château de La Chaize in Odenas.

Realism, faithfulness to their models, pictures of their time: these, I think, are some of the qualities shared by the works in the Louvre reproduced here. Beside treasures from Egyptian and Greco-Roman Antiquity, the majority of the reproductions in this book belong to the high-water mark of classical painting. I like this period as it conforms to my way of thinking about cuisine and being a chef: good, honest fare chimes in with a straightforward kind of painting that preserves the "taste" of what goes into it—with no superfluous trappings or ornaments and no obtrusive intellectualism.

To my mind, the heritage of our past that we have in the Louvre represents the very seedbed of art—a foundation that must be conserved, maintained, and handed down to future generations. Similarly, to preserve the knowledge and skills of an era of great importance for cookery in general, there have to be bastions in which the classic cuisine of Antonin Carême and Auguste Escoffier is kept alive. I do not question the sincerity of certain approaches by contemporary artists, no more than I contest the expertise of chefs who practice what is now called molecular cuisine. Each has its place and, in a period in which the borders between the arts have become increasingly blurred, they may even overlap or merge. In producing ephemeral works, for instance, the artist encroaches onto the terrain of the cook. Meanwhile, with their intricate culinary balancing acts resembling Performance art, certain chefs could work in a museum of contemporary art. Personally speaking, however, I prefer the classics.

Every illustration in *Food in the Louvre* has something to say to me, beginning with those scenes showing animals in their natural state. They represent a dimension in cooking that tends to be forgotten today. Nowadays no one (or almost no one) knows, or indeed is keen on knowing, how to dismember a hare, to gut a fish, to bone and truss a chicken. Homemakers find it beyond them and even cooks are less and less able to do it.

And yet this is an essential aspect of our trade that is gradually dying off. Artists such as Jean-Baptiste Oudry, Nicolas Henry Jeaurat de Bertry, Jean-Siméon Chardin, Francisco de Goya, Frans Snyders, and Eugène Delacroix are not afraid to depict animals in the raw: a freshly shot pheasant, a sheep's head, a ray with an all too human stare, lobsters and hares, fish bubbling away on a stall. These rather brutal images remind us of the fact that, in spite of the sophisticated language that chefs have concocted in an effort to conceal this unpalatable truth, cooking is first and foremost a facet of the struggle for life.

A further category of artworks allots pride of place to farm produce. Although these pictures are known as "still lifes" (and in other languages more unhelpfully as "dead natures"), in fact they endow the fruit, vegetables, and other foodstuffs they show with a singular sense of presence. I am thinking in particular of a canvas by Louise Moillon in which a woman selling fruit and vegetables, presents her finest produce to a wealthy lady customer in a pretty décolleté. These firm-looking artichokes, the divers varieties of cucumbers, the tight heads of cabbage, the peaches at the peak of ripeness, the shiny grapes that Yves Pinard describes so well as "swollen with syrupy juice lean[ing] against others whose bloomy black skin guarantees their quality": all this gives one a fair idea of the sheer quality of produce in seventeenth-century France. What better testimony could one imagine of the ingredients that cooks of the era had at their disposal? These fruits and vegetables look beautiful, but there's no suspicion they might have been grown with the aid of some artificial fertilizer or another. Ah, if only we could get our supplies from the orchards and kitchen gardens of the past!

And Lubin Baugin's dessert of wafers is a beautiful picture too! These slender tubes look nothing like the famous Lyons specialty for which I have a penchant and more closely resemble "Russian cigarettes." We learn from the commentary that they were a delicacy common in the seventeenth century when they would be dunked in wine.

Lastly, some of the works illustrated in this anthology place particular emphasis on the festive aspect. Once again this overlaps with my idea of what cooking should be. Seated around a table with friends, time no longer means anything. For eating is above all sharing in the pleasure of other people's company and many is the time in my restaurant I have noticed how a great meal depends first and foremost on the diners and on the interaction between them. An alchemical process seems to take place whenever people sit

round a dining table, an experience in which each of our "five senses"—to allude to the title of a charming paintings by Frans Francken the Younger—plays a part.

The flowers, the tablecloth, the china, the beauty of the women, the looks of understanding between the menfolk, the aroma rising from the dishes, their savor and consistency: all these elements conspire to create a gastronomic event that delights cooks and painters alike.

Other scenes touch me too, such as the peasant family by Le Nain. If their garments look old-fashioned, other elements and gestures seem timeless: the loaf of bread placed on its front and sliced with a knife by a strong arm; the carafe, wineglass, and pot; the apple core and the domestic animals dutifully awaiting the leftovers. I feel the same emotion in front of Murillo's famous *Young Beggar*. The child, racked by hunger like so many others I have come across here and there during my travels abroad, has at last unearthed a few apples and nuts that might provide him some sustenance. Yves Pinard suggests that the sunbeam is a harbinger of better times to come. We can only hope so. Painting and cookery speak a common, universal language. There's no need for us to communicate to be able to understand one another, and when art decides to depicts food, it reveals its essence, its place in the heart of man, in the intimate recesses of the flesh that he eats, of the flesh that he is.

For a chef, turning the pages of this book is a singularly rewarding experience. It represents a wondrous testimony of a bygone era and captures those little delights in which we all share. Yet it is also a path into the world of art, a pleasure that is visual rather than edible and that satisfies the mind rather than the palate. Thus it offers a food with which no cuisine can hope to compete.

# SELECTED WORKS

Text by **Yves Pinard**

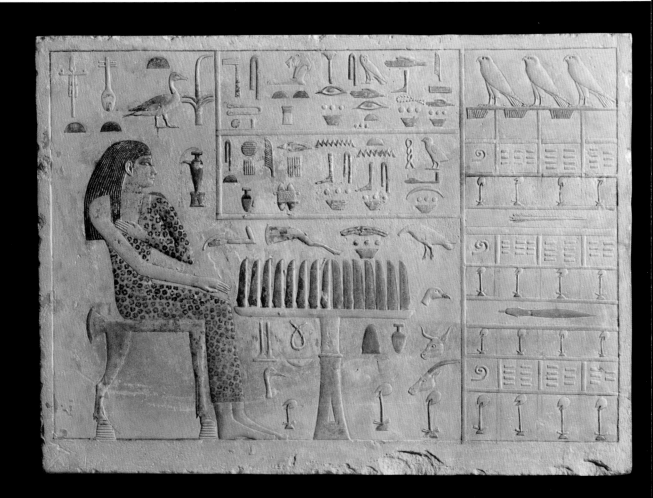

1. *Princess Nefertiabet seated before a meal*
(Facing page)
Reign of Kheops (2590–2565 BCE),
Fourth Dynasty
Painted limestone, 14 ¾ × 20 ½ × 3 ¼ in.
(37.7 × 52.5 × 8.3 cm)

2. *Crockery*
*Jars, dishes, and jar base*
c. 1500–1070 BCE,
early Eighteenth Dynasty
Ceramic, terracotta

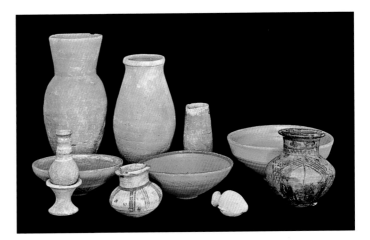

1. The remarkable state of conservation of this piece is striking. The walls of ancient tombs were often decorated with a natural backdrop for the eternal life to come and lined with complete replica of earthly activity: fishing, farming, husbandry, hunting, banquets.… These motifs offer a concise summary of Egyptian customs; given the incredible age of the work, it is surprising to find so much color and even taste in it still. On this Fourth Dynasty stele, Kheops's sister, Princess Nefertiabet, and all that surround her are reproduced with startling precision. Dressed in a skin robe, with her hair particularly neat, she sits on a robust throne supported on hoof-like feet. If her proud, stiff bearing expresses the nobility of her rank, her eyes clearly anticipate the banquet to come.

Dying meant undertaking a lengthy journey, but in this case it looks like a veritable expedition. All her needs are to be taken care of; everything necessary for her daily routine is itemized. Thanks to these substantial offerings, and by continuing to experience the joys brought by terrestrial food, the princess can safely pursue her search for the infinite in the celestial realm forever. The artist has stocked her pantry liberally: with beef, bread, gazelle, haunch of venison, liver, goose, duck, fish, turtle-doves, poultry, fruit, cereals and, no less indispensable, with drinks too. He's forgotten nothing.

This lavish inventory allows us to peruse the menu for a meal that might have been served at a great Pharaonic banquet. There one could savor—among other delicacies—wafers in beer, honeyed gruel, whiting, ful medammas (a fava bean dish), tahini, hummus, molokhia (a soup made from jute leaves), brochette of lamb, pigeon in ferik, fish stuffed with raisins and pine nuts, and figs.

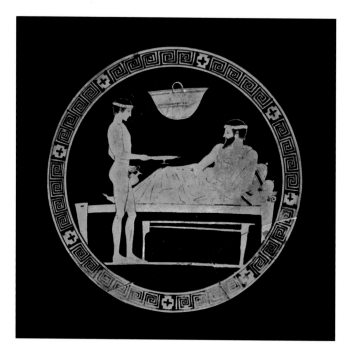

1. EUAION PAINTER
*Red-figure cup*, c. 460–450 BCE
Ceramic, 4 ¼ × 15 ¾ × 12 ½ in.
(11 × 40 × 31.6 cm)

2. *Fragment of a floor mosaic: preparations for a banquet*, 180–190 BCE (Facing page)
Marble, limestone, and *pâte de verre*,
7 ft. 10 ½ in. × 7 ft. 4 ½ in. (2.4 × 2.25 m)

2. This scene of daily life provides us with an opportunity to imagine and experience what life was like in a far-off time. Only an obsession with their craft can explain the patience showed by the talented artists in putting together all these tiny fragments of mosaic. Their art consists in assembling a multitude of tesserae: chips of stone, glass, bone, coral, or ivory fitted together according to shape, thickness, and color.

This mosaic tells the story of how a meal was prepared during the Roman Empire. The actual kitchens are not shown, but the servants and bustling slaves give one a good idea of how they must have been. Someone brings in a fruit basket of ripe figs. A bread porter trips in carrying a basket full of round rolls. A forearm appears brandishing a three-footed terracotta pot, containing a beverage, a piping-hot dish, or water for some important personage's bath. Another still, with a long stick over the left shoulder, advances with a roast on a spit. The last one, a flightier fellow, ensures the drinks service.

All these figures are getting ready for a feast that no one will ever attend. They head in the same direction—to the dining room. They are all barefoot and each is dressed in keeping with his specialty: the fruitier in a simple blouse, the baker in more recherché garb, the spit-roaster bare-shouldered, the wine-porter more warmly clad. Their clothing is cut from the same light-colored cloth and all the garments bear a distinctive trim, which reappears on the carafe, goblet, and pot. This is a sign of ownership. It's an expedient we're used to today, in fact, since it is still practiced in a number of restaurants.

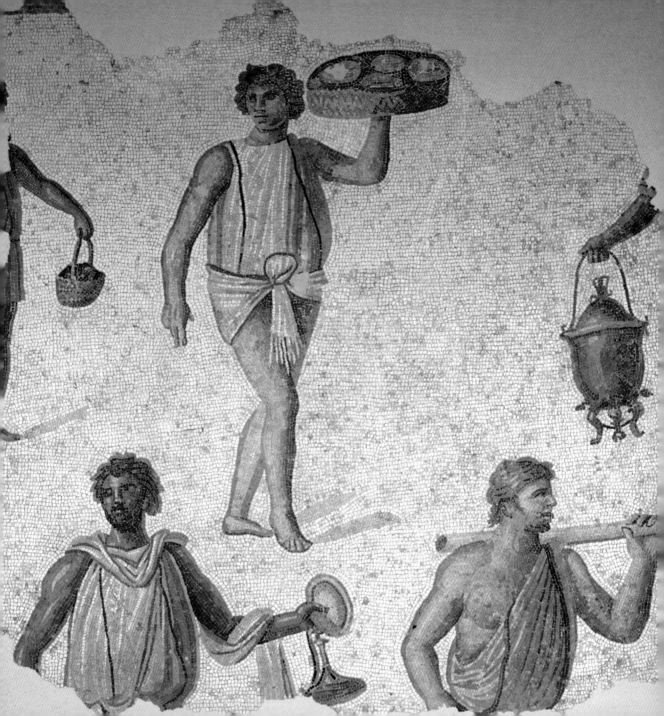

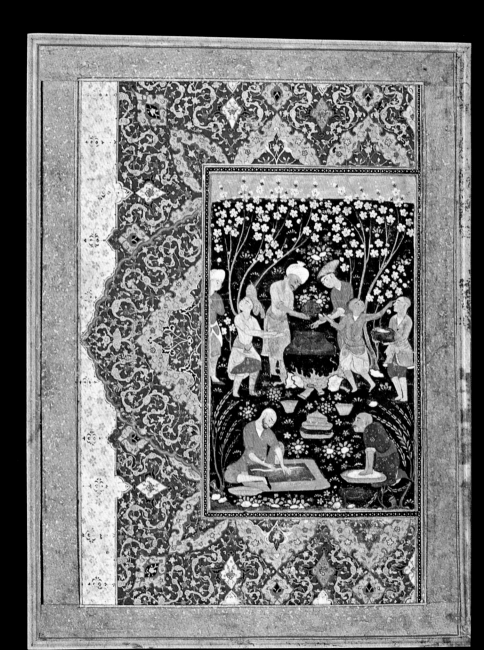

1. *Miniature: Preparations for a meal in the country*
(Facing page)
Second half of the sixteenth century
Gouache, gold highlights

2. *Goblet*
Thirteenth–fourteenth century
Gilded and enameled glass, 4 in. (10 cm)

1. It may sound utopian, but many problems seem to have been solved in this miniature. Looking at it, we are filled by a sense of satisfaction. Treated with a lavishness normally reserved for a religious painting, it shows a concern common to all peoples: the everyday pleasure given by food. Preparing a meal may be agreeable or laborious, but in every part of the world the intention is always the same: conviviality and sharing tastes—though the experience of each individual will be different depending on his or her situation, knowledge, and culture.

This Iranian painting depicts a pastoral collation, a fact confirmed by a background studded with fruit-laden trees that throw a soft glow over the scene. It's a picnic taken in an indefinite space in which various factotums are busying themselves with kitchen tasks. There is neither wall, nor door, nor border. The impression is one of freedom. The only thing that matters is preparing the dishes for the repast to come.

In the foreground, a cook is hard at work carving. The man in the white tunic might be in charge—the chef, no less. He is watching over an enormous pot on a blazing fire, while, in the foreground, another man is crushing seeds or spices in a kind of mortar. All six figures are dressed in the appropriate garb, the young in red trousers and blue tunics, the adults in a longer red tunic and blue pants. An adolescent has joined the team and is piping out a serenade for the guests on his flute.

Food eclipses all else: only the cooks and their assistants are shown, while the illustrious personages who usually appear in such banquet scenes are absent. Social distinctions seem irrelevant; here all are invited to one table to share in a common destiny.

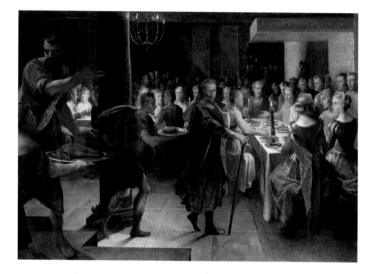

1. **TOUSSAINT DUBREUIL** (c. 1561–1602)
*Dicé Throws a Banquet for Francus,*
c. 1594–1602
Oil on canvas, 4 ft. 3 ¼ in. × 6 ft. ¾ in.
(1.3 × 1.85 m)

2. **TOUSSAINT DUBREUIL** (c. 1561–1602)
(Facing page)
*Banquet Presided over by the King,* n.d.
35 ½ × 33 in. (90 × 84 cm)

2. In the sixteenth century, in a hall with walls and ceiling snugly hung with precious drapes, three tables have been laid, all covered with white tablecloths; at one of them sits the king. Surmounted by a valance decorated with fleurs-de-lis, his table is flanked by two other larger ones for the guests. They are seated in accordance with their rank and the prevailing rules of propriety. Men and women are kept separate, occupying a single side of the table. The king wears a broad ruff, a fashion of the 1560s adopted by women and to a lesser degree by men. The garments of all the diners are heavy with accessories and valuable trappings. The servants' livery is worthy of the quality of the guests.

Equipped with an impressive two-pronged fork, the carver begins work on a bird placed before the king. The master of the royal table who oversees the waiting staff, leaning with one hand on a cane, holds a sword in the other, his eagle eye making sure the table service conforms to the rituals of the household. Behind the monarch, servants attend to his every need. Two halberdiers clear a path for an ambassador carrying letters of accreditation. The servant preceding the envoy is carrying a candle—is that a symbol of plain-speaking and truth? The wine master calls out to a valet to serve a guest who holds out his glass.

At this time, the head chef, in theory a protégé of the king, would have supervised everything down to tiniest detail. The duties of the cooks and waiters employed at such highly ritualized banquets were considered a privilege.

The drawing makes the importance of the hierarchies enforced at court abundantly clear. The nobility was showered with every attention, in particular at table, a veritable institution that demanded service of the highest order.

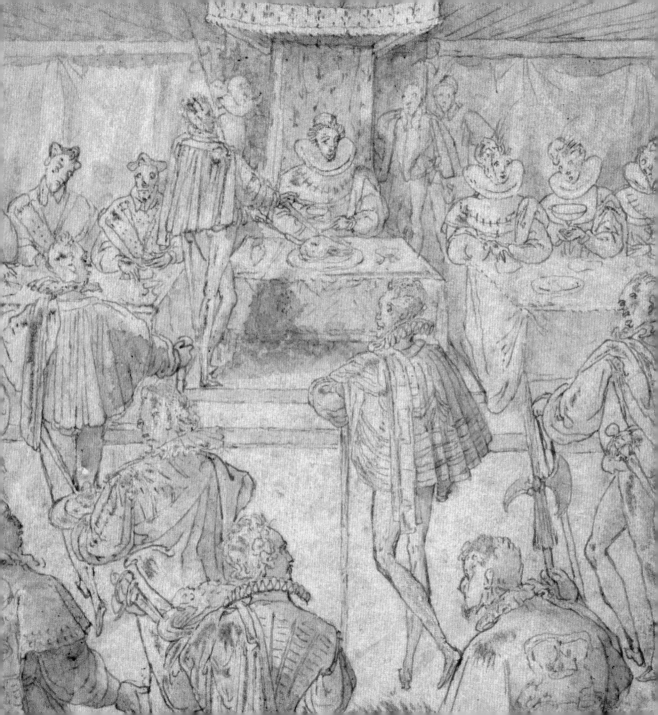

1. *Cup*
Venice, seventeenth century
Plain glass, 6 ¾ in. (17 cm)

2. **LOUIS OR ANTOINE LE NAIN** (Facing page)
(c. 1600/1610–1648)
*Peasant Family in an Interior*, n.d.
Oil on canvas, 3 ft. 8 ½ in. × 5 ft. 2 ½ in. (1.13 m × 1.59 m)

2. The meal here serves as a pretext for bringing together all the members of a family: the parents with their six children. One can imagine they'd be delighted to find themselves all together in this rather sparsely furnished, rustic-looking interior. They gaze out in the same direction, perhaps at the painter immortalizing them on this canvas. The cat and the dog also seem to be enjoying the tranquil scene.

With well-fed faces, each figure appears in rude health, while their garments, soiled by agricultural work, testify to their daily round. The picture speaks of neither wealth, nor poverty. Even the fireplace is complicit in the sense of well-being it exudes, emphasized too by the children's bare feet.

Here, hardship is banished, as attested by the fact that they have a pet dog and a house cat. On the beaten-earth floor stands a *coquemar*, a pot into which the meal which has nearly finished cooking on the hearth will presently be poured. Admittedly the table is laid with no great sophistication, but a spice-pot and the ladle used to draw water from a fountain, obvious signs of relative ease, show that compassion would be misplaced.

The entire family is reunited, perhaps about to say grace and celebrate their love together. Each awaits his or her portion; the mother serves a glass of light red wine and the head of the family cuts the bread. He is slicing *sops* ready to be steeped in the broth in the little bowls. On the menu: a blend of meat and vegetables in a simple stew.

The artist calls this *Peasant Family in an Interior*; one could have just as well have chosen *Preparing the Meal*. The prevailing calm is underlined by the child with the flute who adds the merest hint of poetry to what is a daily ritual. Flitting through the scene, the music he plays is probably a duet of gratitude and prayer.

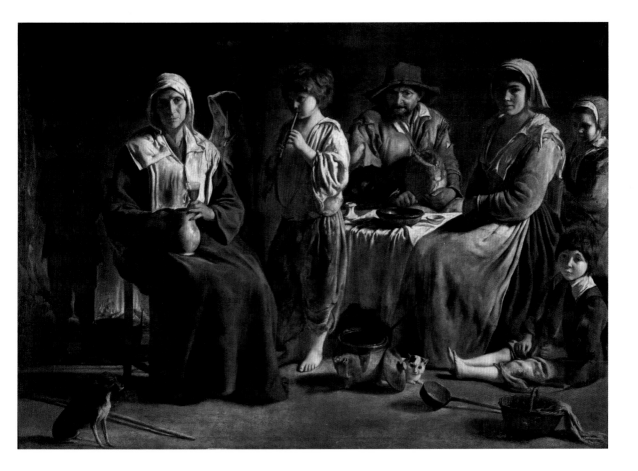

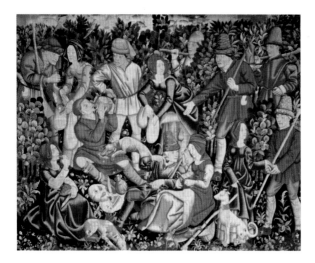

*Huntsmen's Meal*
Late fifteenth century
Tapestry, silk thread, wool yarn,
9 ft. 2 ¼ in. × 11 ft. 5 ¾ in. (2.8 × 3.5 m)

Think of the patience and talent necessary to weave such a tapestry! A mass of tiny strands of linen, silk, or wool, assembled into a hunting scene. We are in the Middle Ages, and the time has come for our hunters to join the ladies, partake of something to eat, and share a few minutes' relaxation together. Two birds make the most of the truce: one boldly spies on the scene, the other flaps off in astonishment.

Repose though is the order of the day and we, like our hunters, need to refresh ourselves with a drink, such as *claré*. A recipe for it has been left by a celebrated medieval cook, Guillaume Tirel, in his famous *Viandier de Taillevent*. Here it has been revised a bit and you might like to try it at home.

**CLARÉ**
*1 oz. (25 g) fresh ginger*
*⅓ oz. (10 g) galangal*
*4 cups (1 liter) white wine*
*7 oz. (200 g) honey*
*1 star anise*
*4 cloves*
*½ tsp. (1.5 g) cubeb*
*1 ½ tsp. (4 g) of melegueta (grains of paradise)*
*½ tsp. (1.5 g) black pepper*
*⅓ tsp. (1 g) long pepper*
*¾ oz. (25 g) whole cinnamon*
*1 ½ tsp. (3 g) green cardamom*
*⅓ tsp. (1 g) strips of mace*

All these spices can readily be found in delicatessens: buy them whole, as seeds, or in pieces. Once you have got your hands on all of them, peel and slice the ginger and galangal and quickly mix with all the other ingredients in a sufficiently large container. Put the mixture aside for at least five days and pass it through a muslin cloth to obtain a clear, golden liquid. A genuine aperitif, *claré* is best drunk thoroughly chilled and accompanied by thinly sliced raw fruit such as apple or pear, or with fresh or dried locally produced fruit.

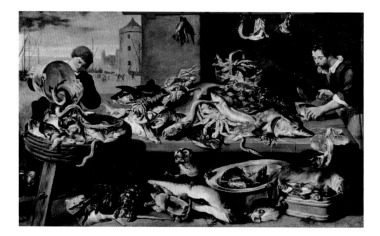

1. **FRANS SNYDERS** (1579–1657)
*Fishmongers at their Stalls*,
c. 1616–1621
Oil on canvas, 6 ft. 10 ¾ × 11 ft. 2 ½ in.
(2.1 × 3.42 m)

2. **ABRAHAM VAN BEYEREN** (Facing page)
(1620/1621–1690)
*Still Life with Carp*, c. 1646–1650
Oil on canvas, 28 ¾ × 24 in. (73 × 61 cm)

2. The precision of the details the artist has
lavished on these fish makes us think that
he must have been rather partial to the
finny tribe. His carp—a common carp—
is enthroned like a trophy above a pile of
other freshwater species, perch and pike,
strewn higgledy-piggledy over the table.

Originating in Asia, the carp was
introduced into Europe by the Romans.
Then, in the Middle Ages, monks released
them to swim in pools in their monasteries
or had ponds dug to breed them. This fish
is the most widespread fish in the world,
often appearing in meals on Jewish festivals.

CARP À LA JUIVE
*1 carp weighing 2 ½ lbs. (1.2 kg)*
*4 onions*
*2 cloves of garlic*
*1 bunch of parsley*
*1 sprig of chives*
*2 tbsp. dill*
*Scant ½ cup (10 cl) olive oil*
*2 ½ tbsp. (15 g) flour*
*1 ¼ cups (30 cl) water*
*2 tbsp. raisins*
*Fine kitchen salt*
*Freshly milled white pepper*

Gut and clean the carp and cut it into
sections. Slice the onions into slivers.
Chop the herbs and garlic. Heat the oil in
a casserole, add the flour, stir well and
cook gently to obtain a white roux. Add
the water, mix well, then add the onions,
garlic, herbs, and raisins. Season with salt
and pepper. Add the carp slices and cook
for around 20 minutes. Drain off the fish
pieces and lay them in a hollow dish.
Reduce the jus stirring carefully on a high
flame, then pour over the fish pieces.
Spread evenly and skim; allow the dish to
cool in the refrigerator until serving.
Once cooled and jellied, the dish can be
served as a cold entrée.

This is a simple recipe best prepared well
in advance.

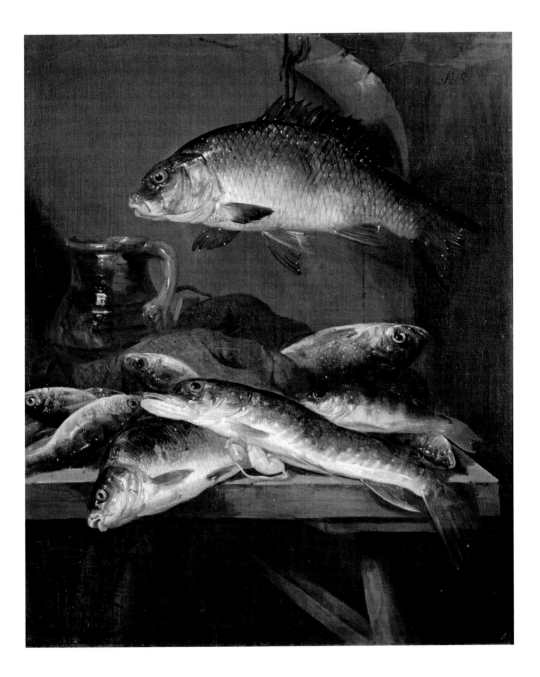

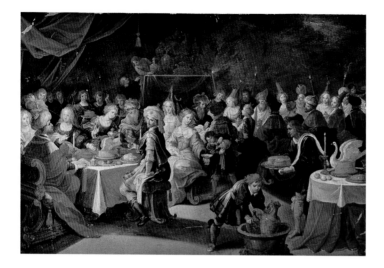

**FRANS II FRANCKEN,** *KNOWN AS*
**FRANCKEN THE YOUNGER**
(1581–1642)
*Belshazzar's Feast*, seventeenth century
Oil on copper, 14 ¼ × 20 ½ in.
(36 × 52 cm)

The cave that serves as a backdrop to this scene has clearly been arranged and decorated in a manner in keeping with the event. The banquet illustrates an episode in the Bible featuring King Belshazzar. At the rear can be seen amphorae still partly buried in the earth, probably to keep the contents fresh. Ample hangings fall from the vault and the furniture is laid out in an Oriental-style interior. Some of the guests also sport Oriental garb, expensive garments cut in cloth of the highest quality; velvets, whose gleeful sparkle dances over the picture. The accessories

are well crafted, the throne and the chairs are gilt. There's a glazed earthenware ice bucket, with ewers, and slender candlesticks lighting the scene. The guests seem happy enough to partake and the dishes brought to them must surely contribute to their pleasure. Waiting staff arrive with fruit, tiny roasted birds on faience plates, meat pies on silver platters, and even a peacock and a swan "in birdcage."

A truly select table with guests of such quality deserves a recipe like the "Pheasant" from the famous book, *Le Cuisinier françois* (1651), by La Varenne, which the talent of the artist accurately represents in the guise of a swan. Nowadays no one tucks into swan or peacock, whose stringy flesh makes for poor eating, but La Varenne's pheasant can still be appreciated by everyone.

"Blanch it on the fire, that is, put it back on the grill, and, setting aside a wing, the neck, the head, and the tail, stick it with bacon pieces, wrap it in the feathers with butter-coated paper. Cook, serve and garnish."

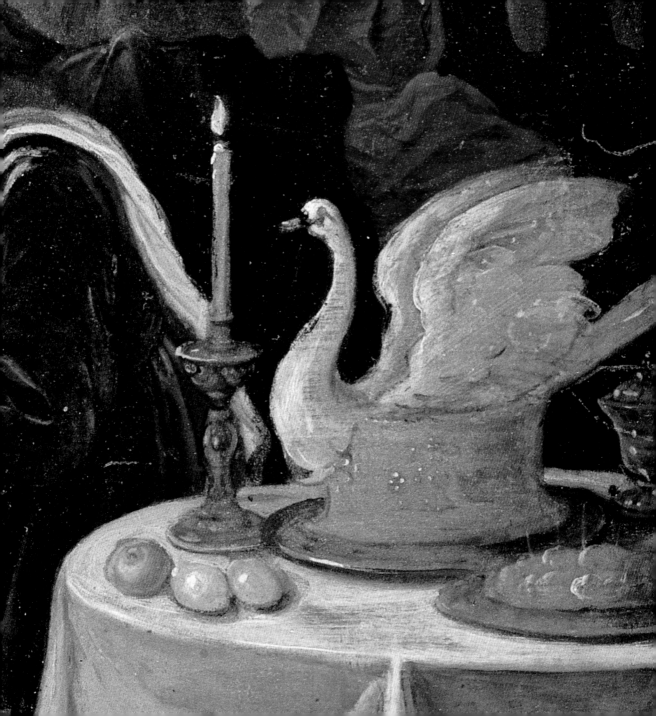

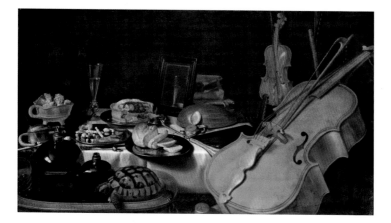

PIETER CLAESZ (1597–1660)
*Still Life with Musical Instruments*, 1623
Oil on canvas, 27 ¼ × 48 in. (69 × 122 cm)

To judge by the open watchcase and the window reflected in the liqueur bottles, the artist painted this picture some time in the late morning. The inventory features a host of musical instruments, objects, and foods. Let us savor the food, be lulled by the melody, and take a closer look at what precisely the painter has depicted.

A wan halo of yellowish tinge—a white tablecloth that barely stretches over half the table… But having spotted the head of a mouse peeking out, the contents of the earthenware goblet on the silver centerpiece become suddenly less enticing. Is it the painter who's teasing or are my eyes on the blink? On one of the silver platters, some crumbly white bread, neatly sliced; on another, a tasty-looking pie stuffed with birds and whole mushrooms in a clarified sauce and no doubt smelling delicious,

a challenging recipe requiring deftness and an alert eye at the oven. On the last are sweetmeats—biscuits and divers confections.

But make way for the music! Imposing its tempo, a plump cello tinted with bright varnish ensures us of a warm voice. Unmissable and the center of attention, it pays little heed to the more skittish violin. Proudly, it proclaims its woody origins, and with soul and talent, transforms the caresses of the bow into a crystalline stream of notes. Its colorful volutes are rolled out on the canvas for all to see. Enraptured, prone on its belly, the resting lute lends an ear to the concert. The self-regarding, elegant flute is reflected in a mirror standing on some old books in front of a glowing wick and a venerable silver snuffbox. Lastly, trustworthy and wise, a tortoise relishes the lickerish harmony of the painter's musical talents.

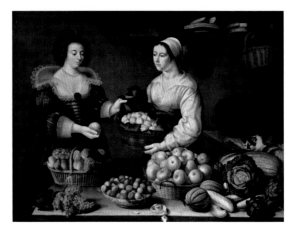

**LOUISE MOILLON** (1610–1696)
*The Fruit and Vegetable Seller*, 1630
Oil on wood, 3 ft. 11 ¼ in. × 5 ft. 5 in. (1.2 × 1.65 m)

Fruit and vegetables are hugely important foodstuffs. If people in the countryside are able to acquire them relatively easily, things have always been more complicated for townsmen. In former times, greengrocers would sell only what was in season—as here, in autumn. This picture shows two women: a fruit and vegetable seller and a richly dressed customer. The greengrocer seems to know the lady well and offers her a basket of her finest fruit arranged among some leaves that serve at once to preserve, garnish, and package them.

Autumn, a bountiful season, is close at hand and the customer seems overwhelmed by what's on offer. She prevaricates between the glorious peach and sundry other fruit; bright bunches of grapes swollen with syrupy juice lean against others whose bloomy black skin guarantees their quality. Another of greenish hue is for pressing verjuice, a sour-tasting, liquid flavoring then much appreciated. Magnificent wild strawberries, three nicely ripe peaches, whose velvety skin harbors pinkish flesh typical of autumn varieties. Fine-looking, ruddy plums, their stalks torn off and lazily secreting their sap, apples bracing themselves for insect attack, two firm melons harboring sugar-laden flesh, cucumbers of all stripes advertising—without great assurance—their bland innards … A visitor from another continent, a pumpkin, timid in spite of its rotundity, keeps himself to himself at the edge of the canvas. Marrows, oversized gherkins, artichokes with bristling leaves, firm-hearted green cabbages … all these vegetables are draped in the morning dew, that unquestioned warranty of freshness.

The stallholder also sells cheese which, wrapped in vine leaves and macerated in olive oil, would serve as an excellent epilogue to the pretty customer's meal. A suggestion would be to accompany the cheese with the slightly dry-looking bunch of grapes hanging at the back of the picture.

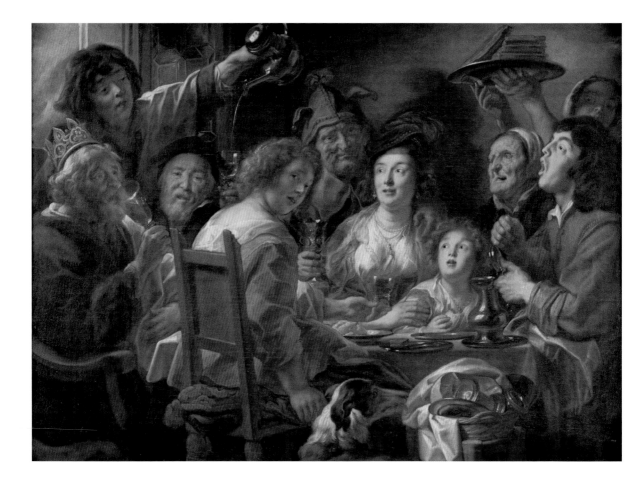

1. **JACOB JORDAENS** (1593–1678)
(Facing page)
"*The King Drinks*," or *A Family Meal
on Twelfth Night*, c. 1638–1640
Oil on canvas, 4 ft. 11 ¾ in. × 6 ft. 8 ¼ in.
(1.52 × 2.04 m)

2. **JAN STEEN** (1626–1679)
*A Merry Family Meal*, second half of
the seventeenth century
Oil on canvas, 32 ¼ × 26 ¾ in. (82 × 68 cm)

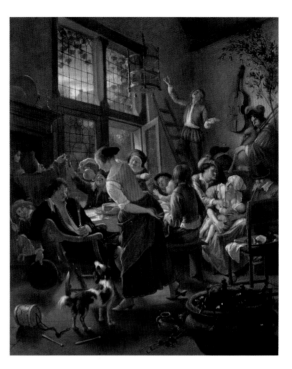

1. One would love to take a seat in this picture and partake of its conviviality. It's a great scene and the whole company is buoyed up by a sense of postprandial fellowship. Here, due homage has been paid to tradition and the "king" has discovered the bean, the biblical pretext for which our protagonists have been gathered together. In the English fashion, a toast is raised to the lucky winner. On the table there is still a little cake of traditional bake eaten at Epiphany. It resembles the famous *gorenflot*—from the name of the monk who invented it by putting leavened dough in a terrine in which the bean (elsewhere a coin) would be hidden. This is the ancestor of the French *gâteau des Rois* that appeared some time around the sixteenth century, the famous *galette frangipane*—puff pastry filled with cream of almonds. Certain regions have kept faith with their old brioche "crowns" (*couronnes*) with candied fruit. Even if puff pastry was invented in Italy, the idea it arrived in France only in the sixteenth century is incorrect, since it was already well known in the fifteenth.

In our day, such traditions have become blurred and are often only kept alive by money-spinning schemes. So this custom has been perpetuated with some inventive variants. The one-time bean, a mere vegetable, is replaced by a plaster figurine illustrating a religious theme. Nowadays, they represent the most varied subjects and are generally in molded plastic, though they can be of better stuff or even replaced by gold coins!

At the time this picture was painted, the guild of pastry-cooks and the company of bakers had long been separate—rival corporations: one having a monopoly over cakes and the other over bread. A mischievous bunch, the latter liked to point up the schism by presenting their finest bakes to their suzerain.

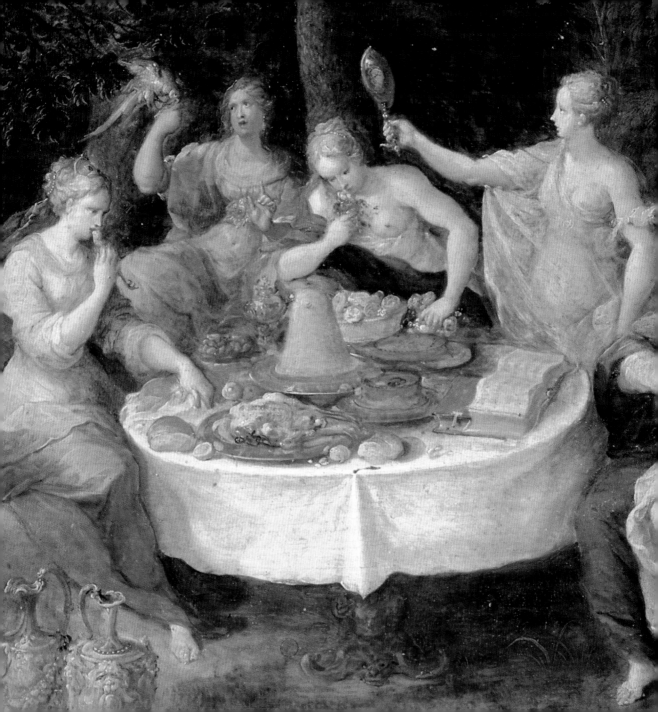

**FRANS II FRANCKEN,**
***KNOWN* AS FRANCKEN THE YOUNGER** (1581–1642)
*The Five Senses*, first half of the seventeenth century
Oil on wood, 22 × 33 ¾ (56 × 86 cm)

This picture immediately places our senses on alert. The artist invites us to take our ease. Standing to the right, a woman gazes at herself in a dainty looking glass. Like the others, she is elegantly attired, apparently sporting one of these gowns that worked wonders on a favorite of the king of France.

Our sense of smell is aroused by a heady wind borne in from the countryside. Lip-smacking aromas arise from the table and the luxuriant scene is enveloped in a gentle melody, a harmony composed of fleeting notes plucked by the slender fingers of a pretty lute-player. She accompanies her crystalline voice, while the birds of the air twitter away merrily, adding Nature's revels to hers.

It's unbearable. The temptation is to make a move for all these fruits of the good earth laid out on the tablecloth. Epicure? In such attractive company, the word hardly comes as a shock. But where to start? Meat pie, glinting, golden poultry, dessert wine, sugar loaf, or the pyramid of fruit in front of the scantily clad young beauty? All inflames ones desire. We stretch out a hand—but is it a tidbit or the parrot? My hand rummages around in the soft plumage. It's perturbing. Still, its many attractions conspiring, the canvas proffers an invitation. The daffodils and the lilies add visual pageantry to the scents; oaks rustle their leaves; the sky and the river ripple through the scene with an exquisite caress.

Each time one looks, one spots some half-forgotten detail. Faced with such a spread, there are no easy choices. It is hard to resist the pleasures of the palate. What one really wants to do is climb into the picture with all five senses. The backdrop is magnificent, and given added luster by the five belles, all keen that we should follow the five-fold path to contentment.

**LUBIN BAUGIN** (1612–1663)
*The Dessert of Wafers*, c. 1630–1635
Oil on wood, 16 ¼ × 20 ½ in. (41 × 52 cm)

In the seventeenth century, waffles were appreciated in all social classes. The crockery, the glassware enriched by remarkable motifs, the elegantly decorated tinplate dish with raised rim—pieces made by talented craftsmen—usher us into a well-heeled interior. A bottle containing a wine of fine color and enwrapped in wickerwork brings a breath of the South. This nectar, the result of centuries of expert viniculture, was commonly called dessert wine. Wine and wafers were in fashion in the seventeenth century and one would dunk the biscuit, being careful not to lose a single drop of the precious nectar.

The *snaps* or *gaufres* here look remarkably dainty. The mixture, after being carefully sieved through a linen cloth (purity was paramount), is then run between two hot wafering irons. In this period, they might have been sweetened, but it was not uncommon for cheese to be added. It was in the Middle Ages that this concoction reached its apogee. Indeed, if the Belgians came up with the idea again in the eighteenth century, medieval vendors of *oublies* (thin waffles) had hawked them in French streets several centuries earlier. All these wafers—*gros bâtons*, *gaufres*, *oublies*, and *gimblettes*—needed to be cooked to perfection. One could tell by their color, as here. Once cooked, the waffles would be rolled like cigars. They seem rather flimsy and one would be advised to pick them up cautiously. But the temptation to have a try is hard to resist. Bursting over one's tastebuds, their delicate sugariness morphs into a funny bubbling sensation which, as the wafer comes into contact with the tongue and disintegrates, explodes in the palate into a multitude of miniature delights.

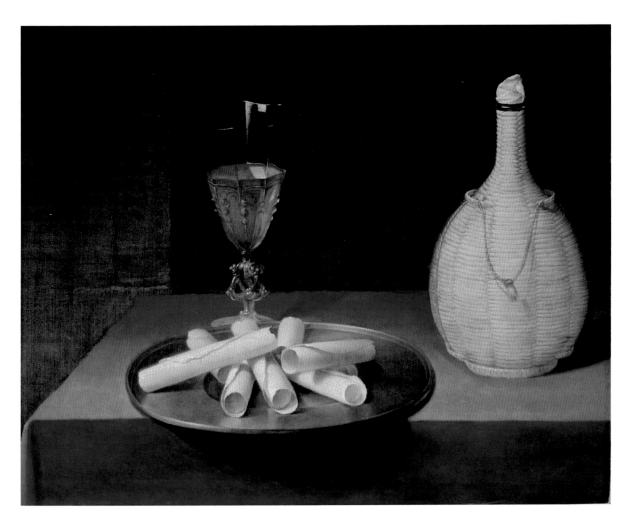

## BRIOCHE AND FRUIT COULIS
### PASTRY DOUGH
*1 lb. 1 oz. (500 g) flour*
*½ oz. (14 g) baker's yeast*
*Scant ½ cup (10 cl) milk*
*6 eggs*
*1 oz. (30 g) caster sugar*
*2 teaspoonfuls of natural sea salt*
*1 ⅓ cup (300 g) butter*

### COULIS
*1 ½ lb. (750 g) peaches*
*½ lb. (250 g) cherries*
*1 ⅓ cup (250 g) sugar*
*½ cup (10 cl) water*
*3 ½ oz. (100 g) wafers*

Carefully knead the flour, yeast, and milk. Incorporate the eggs, sugar, and salt. When the dough leaves the sides of the bowl clean, add the butter and knead until the dough no longer sticks. Remove and put in a bowl. Cover and allow to rise to double its volume for 10 hours at 77°F (25°C).
Fold and ram with the heel of the hand; fold in once more. Divide into two balls, of about 1 ½ lb. (750 g) and 7 oz. (200 g). Roll each ball in well-floured hands. Take a 2-pint (1-liter) mould. Butter the sides well and place the larger ball in it. Squeeze the smaller ball down on top of it to form a pear shape. Let it come to at room temperature for 30 minutes. Brush lightly with egg yolk and cook for 30 minutes in a preheated oven at 320°F (160°C). Remove the still warm brioche from its mould.
Make the coulis by simmering the peeled and stoned fruits with sugar for a good long time. Add water and whizz in the blender. Crumble the wafers and scatter them in the cool coulis. Serve the coulis separately with the brioche.

1. **ABRAHAM BOSSE** (1602–1676)
*The Suite of Trades: the Pastry-Cook*, c. 1635
Engraving and etching 10 ¼ × 13 in. (26.2 × 33.2 cm)

2. **JEAN-SIMÉON CHARDIN** (1699–1779)
*The Brioche*, 1763 (Facing page)
Oil on canvas, 18 ½ × 22 in. (47 × 56 cm)

The succulent brioches baked by Gaston Lenôtre would certainly have delighted the painter. But would the celebrated pastry chef have given mine his approval?

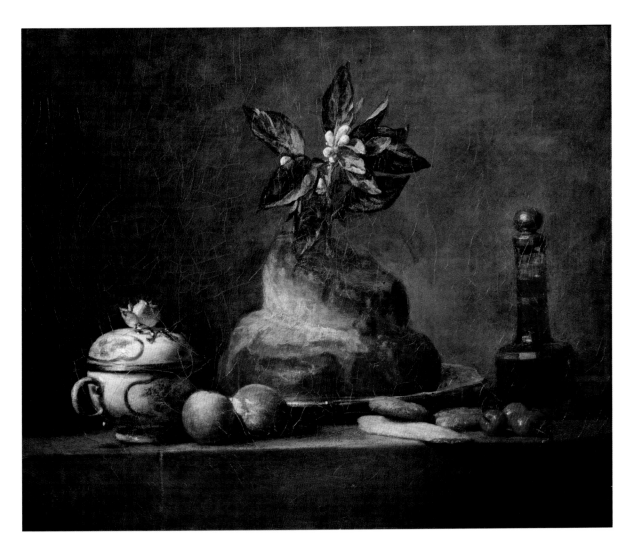

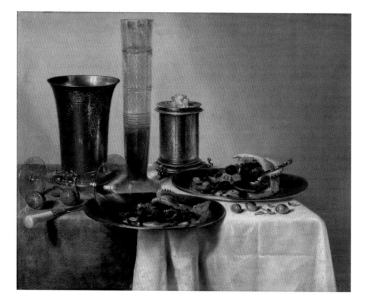

WILLEM CLAESZ HEDA (1594–1680)
*End of a Collation*, also known as
*A Dessert*, 1637
Oil on wood, 17 ¼ × 21 ½ in. (44 × 55 cm)

This picture pulls us in two directions: there are two sources of light, two ways of using a goblet; and the salt cellar—is it actually filled with salt or sugar? Has the tablecloth been folded back or is it just too narrow? Even the table is of two colors; the knife both invites and keeps at bay; and that pie … sweet or savory? Ah, choices!

Oppositions aside, the choice china parades the fact that we're in a household with money to spare. The solidly worked beer glass has been subjected to daily use; facing it comes a pot with a neatly engraved cylindrical body of ecclesiastical air. The master craftsman's hand has scarcely grazed the metal. No less richly adorned, the elegant plinth at its foot should contain salt, it seems, an essential food product that has sown its fair share of discord. A magnificent tumbler, a goblet on which the goldsmith has chiseled what looks like the owner's name. A knife with its wide, shiny, tempered-steel blade stands guard over the delicacies. The bone or mother-of-pearl handle fits into a minutely engraved silver ferrule.

Two serving-bowls, dishes or plates, in silver too—or perhaps just tin—vainly trumpet their expense in the face of the paucity of their spoilt contents. Unabashed, the silver spoon has made inroads into a leftover pie that even the natural exuberance of a few hazelnuts and walnuts cannot quite revive. In this relaxing interior, the desire to show is motivated solely by a concern with appearances.

Looking at this canvas, one is forcibly struck by one fact. Good and evil—materialized here by savory or sweet. The first then represents need, the second pleasure. Sustenance is ousted, overwhelmed by opulence. Scornfully, the prosperous turn away from a simplicity that only meditation can provide. Because, finally, this chill piece, laden with bounty, lacks scent and savor. But again, perhaps this is due to the calculated indifference of wealth.

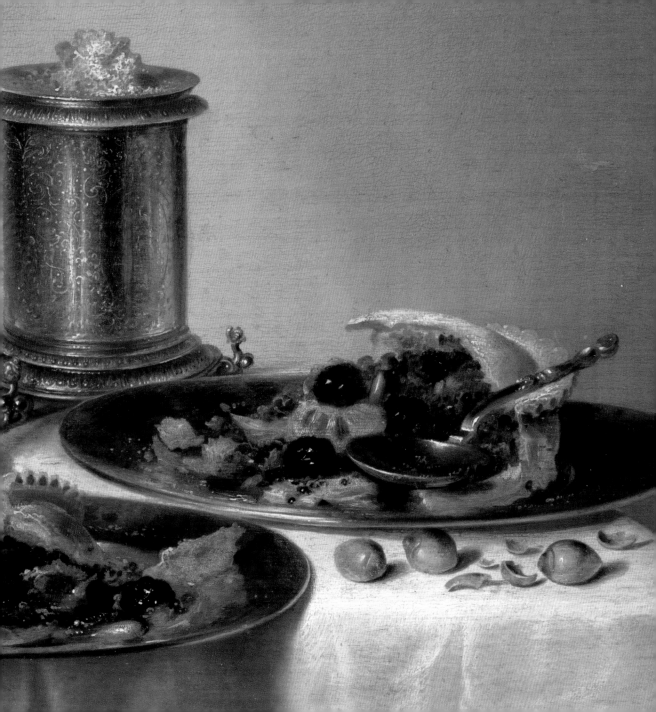

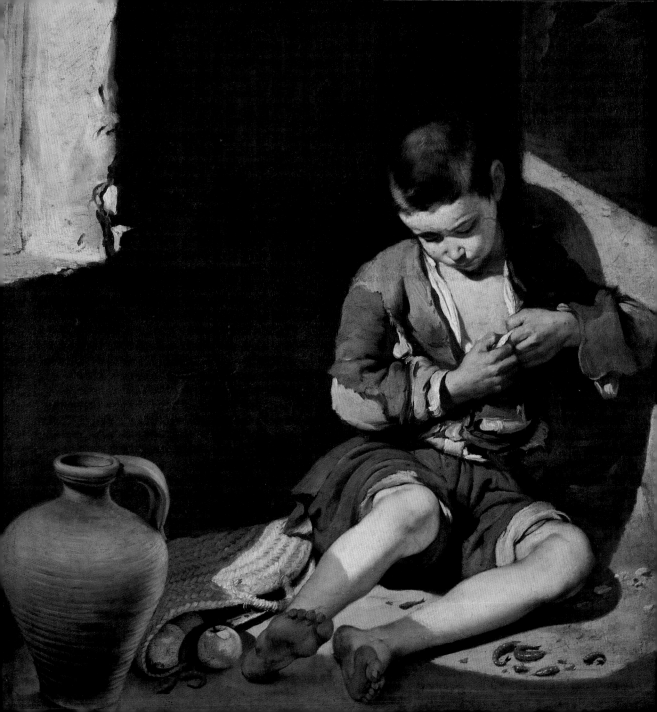

**BARTOLOMÉ ESTEBAN MURILLO**
(1618–1682)
*The Young Beggar* (also known as
*The Beggar Boy*), c. 1645–1650
Oil on canvas, 4 ft. 4 ¾ × 3 ft. 3 ¼ in.
(1.34 × 1 m)

At the end of his tether, an exhausted boy
spends his youth imprisoned in poverty.
His tattered clothes speak amply of his
adversity. Grubby, unshod feet, the onset
of spot baldness: everything reflects a truly
desperate existence. Picking noisome
insects from his rags, a captive of total
indigence, in all probability he is not
above pilfering to survive. The scraps of
food and the water jug lying on the
ground are all he has for his subsistence.

Apples tumbling out of a straw basket and
a handful of shrimps hold out the promise
of some hope, however. The epitome of
freshness, the adolescent's boyish face too
seems unaffected by his plight. He is a
picture of resignation and one can but hope
that the insouciance of his age will help him
bare his unjust burden.

But surely one day the child will find the
strength to make good his escape and
make his entrance into the great theater of
life. The open window is already an
invitation. He might soon leap over the
wall to freedom and enjoy the benefits of
the sunshine outside. One can trust that
the child will then be able to enjoy the
pleasures of an ordinary life, agreeably
enhanced by those of a well-stocked table.

**A POSITIVE EPILOGUE**
*6 apples*
*1 ½ lb. (750 g) shrimps*
*1 lemon*
*½ bunch of chives*
*½ cup (10 cl) full cream*
*2 tsps. mustard*
*Chervil*
*Salt, pepper*

Peel and dice the apples. Dip them in
lemon water and mix the shrimps, apples,
and chives in the cream and mustard;
season to taste. Garnish with a sprig of
chervil; but is this even necessary? I'm sure
our beggar-boy would prefer this salad as
fresh as it can be.

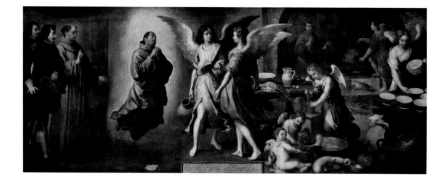

**BARTOLOMÉ ESTEBAN MURILLO** (1618–1682)
*The Angels' Kitchen*, 1646
Oil on canvas, 5 ft. 10 ¾ in. × 14 ft. 9 ¼ in. (1.8 × 4.5 m)

The recipe of life is rather complicated in this picture. Split into two natures, the existence of both is enhanced by the food they share. Two well-heeled figures leave their earthly lives, preceded by two Franciscans, one opening a door that was bolted from the outside, while the other recites the prayers that will allow their progress. No obstacles hinder their leave-taking from the sublunary world: the emblem one of them is wearing has surely smoothed their path. The almost quizzical glance of the other reminds one of the seriousness with which this formality—a requisite for all those desirous of attaining paradise—has to be approached. A piece of paper with a short text casually thrown to the floor has already been examined: it is not incriminating and the gentlemen have clearly been permitted to go on their way and pursue their quest.

Time has no power in this indefinable place. Yet the need to feed oneself still holds sway. In a realm between "heaven and earth," they will have to wait, regularly served a cuisine concocted by angels, immaterial beings whose culinary talents are oddly similar to ours. Bowls on trays, a wood-burning stove ablaze, diverse foodstuffs, a real kitchen: nothing surprising there. With what are they preparing to gratify our two travelers? Anticipating their pleasure, let's imagine a grand lamb stew with the full complement of vegetables, and inhale the aroma wafting up from the meat and breathe in the pungent herbs. Enrapturing, their filtered scent percolates through the steam pouring up from the bubbling bouillon and echoes the contagious serenity that seems to characterize the youthful cooks.

Fully occupied our angels smile kindly, reflecting the joy that infuses this divine world. As for cookery—if it's that of the angels, it reassures the two candidates. It might even help us accept ours when our time comes.

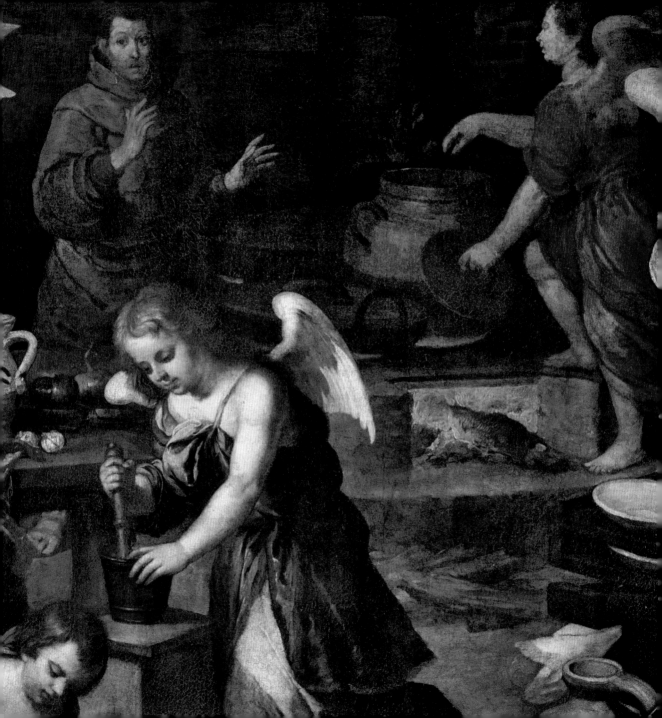

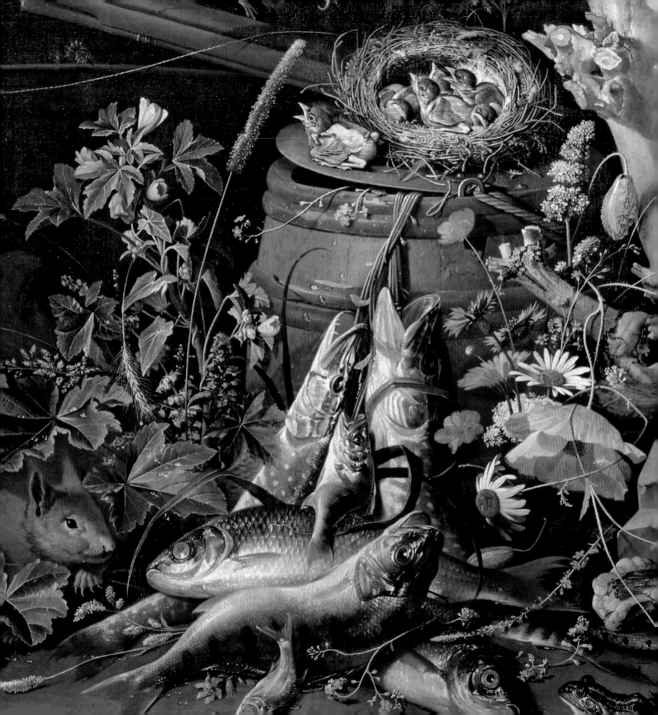

**ABRAHAM MIGNON** (1637–1679)
*Nest of Redstarts*, n.d.
Oil on canvas, 32 ¼ × 39 ¼ in. (82 × 100 cm)

There's so much detail in this picture. Creepers tangling with trees, summer blooms and fish, amphibians and reptiles, the sandy soil. And the painter has set the scene for all these pastoral symbols in a forest near a cereal field on the banks of a river close to the sea at low tide!

Confusion reigns: a heap of lifeless fish, querulous frogs, a squirrel squirreling away under some leaves, a meditative crayfish, snails fearful of the chinks in their armor, and, swinging by a leg, a squirrel and a moorhen share a similar fate. Inches below, two snakes bump into one another at the corner of a large stone, a kind of broken stele, but their show of aggression is simply the reflection of a legitimate mutual fear.

Mushrooms occupy the limelight in the foreground: thimble fungus, *Verpa conica*, as well as *Boletus pinophilus* (pine boletus), among which patrol small amphibians. A profusion of plants sprouts between the animals: flowers of the field, poppies, daisies, and cornflowers, cereal ears; tree trunks, wild cabbages with expansive leaves, efflorescences of bulrush and club grasses, carefree dragonfly of whence she came.

Life red in tooth and claw, where each uses the other to keep alive: this is the true subject of this teeming canvas. Regretfully, hopefully perhaps, fishing and hunting are both represented as brutal necessities. One sees a rifle butt and a barrel of light-colored wood in which the finches have made their nest.

Five nestlings chirp like mad, and one, in all too much of a hurry, has fallen out. The little birds call out to their mother under the watchful eye of her mate. Striving to live, driven to survive; in their desperation to avoid death, every creature ransacks nature. Life, that story without end, takes place on a stage on which the only players are nature and hope.

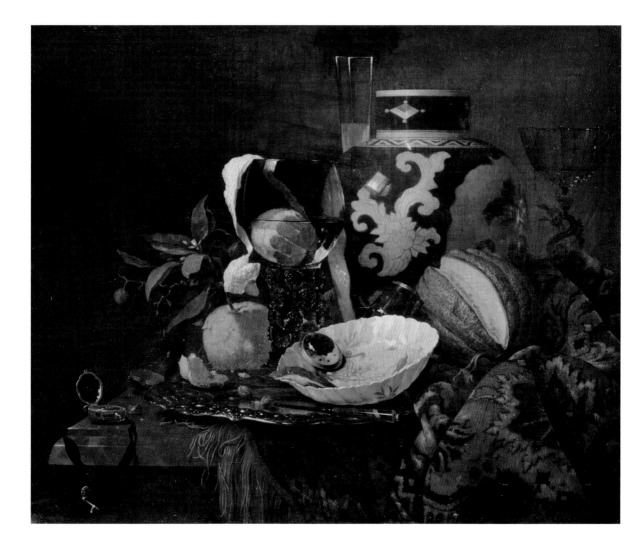

1. *AFTER* WILLEM KALF
(1619–1693)
*Still Life with a china vase*, c. 1655–1665
Oil on canvas, 22 ¾ × 28 (58 × 71 cm)

2. *PAIR OF LIDDED POTS*
c. 1710–1725
Chinese porcelain with Imari
decoration, bronze mount,
h. 11 × d. 9 in. (28 × 23 cm);
h. 12 × d. 10 in. (30 × 25 cm)

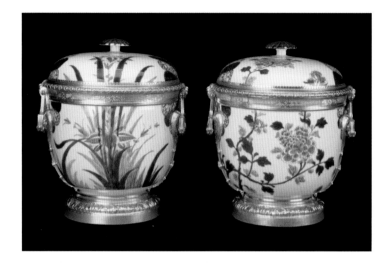

1. The canvas is invaded by the sweetish
odor of melon, keenly exacerbated by the
tartness of a lemon in its peel. The scent is
made still more appealing by the opulent
utensils on the table, including the China
vase, whose cachet vies with its beauty.
Languishing on a richly woven rug, the
melon is temptation itself.

Throughout history the melon has been a
food of choice, though medicine has been
more ambivalent, sometimes prohibiting,
sometimes revering it. It has to be confessed
that, contrary to good sense, it was greedily
consumed in vast quantities. Eaten
morning, noon and night, people—in a
word—seemed to have "stuffed" themselves.
Then there were the erotic connotations
some naughtily lent to this fruit.

Originating in Africa, it reached China (no
one knows how), eventually being brought
to France from Cantalupo near Rome by
Charles VII. Summer is its prime season, but
imported from all four corners of the world
it is now stocked year-round: its quality
might suffer, but there are profits to be made.
Try this recommendation from Henry IV of
France with a really fresh specimen:

**MELON SOUP WITH MUSCATEL AND BASIL**
*1 good, ripe melon*
*12 basil leaves*
*1 cup (25 cl) Muscatel*

Slice the melon into two, remove the pips
and spoon out the flesh with a scoop.
Place in a bowl, chop the basil finely,
scatter it over the melon and pour on
the Muscatel. Mix thoroughly and place
in the refrigerator. Serve well chilled.

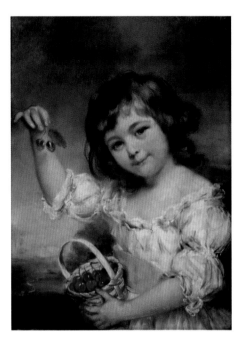

1. **JOHN RUSSELL** (1745–1806)
*Little Girl with Cherries*, 1780
Pastel, 23 ½ × 17 ¼ in. (60 × 44 cm)

2. **FRANÇOIS GARNIER**
(1600–before 1658) (Facing page)
*Bowl of Strawberries and Basket
of Cherries*, n.d.
Oil on canvas, 20 × 25 ½ in. (51 × 65 cm)

1. The artist is weighed down with talent and his efforts deserve careful attention: the carefree youth of this elegant little girl floods the canvas, a living, breathing specimen of one of those doll-faced porcelain figures of the period. The picture invites us to identify with this tranquil scene and join in a moment suspended in time, remembering it as the epitome of joy. With consummate grace, the little girl hands us some lovely fruit—freshly picked, as the leaves and bright green stalks prove. She wears a gorgeous, light-looking dress, scoop-necked and puffy-sleeved, that the dressmaker, like a goldsmith, has embellished with ample tucks and festoons. The dress is waisted with a broad blue belt from which springs a multitude of nonchalantly gathered pleats. One could never tire of such enjoyment and glowing health. But what arouses greater admiration? The invitation to plunge one's hand into the basket of cherries? Or the sweet little girl's expression? Best to enjoy it all without forethought, in childlike simplicity. And tuck into some of the glorious fruit.

The return of the red cherry, bursting with sweetness, sugary and energy-giving—enough on its own—has long been hailed with gladness. There exist sourer varieties: the culinary amarelle and the griotte. Originating in Asia Minor, there are two species of the tree, the sweet wild cherry or gean and the tarter griottes. Already widespread in Antiquity, it was eaten off the bough, wild, before being cultivated in the Middle Ages. In the eighteenth century, Louis XV encouraged the development of many varieties, including bigarreaus and early burlats. If the fruit that heralds spring is familiar, what is less known is that the stalk and flower, once dried, can be brewed as an infusion and that in the United States great store is put by it in dentistry.

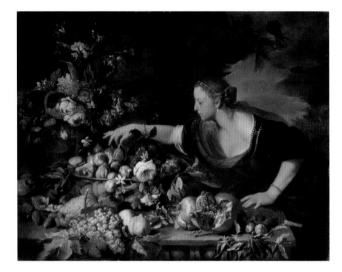

**FIGS AND PAIN DORÉ**
*12 oz. (350 g) dried figs*
*6 thick slices of brioche bread*
*⅔ cup (80 g) granulated sugar*
*⅓ cup (50 g) currants*
*1 vanilla pod*
*2 star anise*
*3 ½ oz. (100 g) fresh grapes*
*2 apples, diced*
*2 ½ cups (50 cl) cream*
*3 egg yolks*
*⅓ cup (70 g) butter*
*4 ½ tbsp. (60 g) brown sugar*
*Pralin (ground caramelized almonds;*
*optional)*

1. **ABRAHAM BRUEGHEL** (1631–1697)
*Woman Taking some Fruit*, 1669
Oil on canvas,
4 ft. 3 ½ in. × 4 ft. 10 ½ in. (1.28 × 1.49 m)

2. **LUIS EUGENIO MELÉNDEZ** (1716–1780)
*Still Life with Figs*, n.d.
Oil on canvas, 14 ½ × 19 ¼ in.
(37 × 49 cm)

2. Insolent in their freshness, these figs seethe with juice. Some have burst with joy in the sunshine, displaying their delectably sugary innards for all to see.

The Romans would eat them with ham. Dried, they were mixed with raisins by suppliers to Venice, a rather dubious trade stigmatized as *mi-figue, mi-raisin* ("half-fig, half-raisin"—that is, "neither one thing nor t'other," "neither fish nor fowl").

Let us offer these figs: roasted and coated in a *raisiné*, balanced on a slice of golden toast.

Leave the figs to soak for 6 hours in warm water. Remove the crust from the slices of bread. In 2 pints (1 liter) of water, cook the figs, granulated sugar, currants, vanilla pod, and star anise for 20 minutes. Put aside 18 figs. Take out the spices. Return the liquid to the hob together with the fresh grapes, the diced apples, and cook thoroughly. Once the syrup has almost disappeared, blend to obtain a relatively consistent coulis: that is, a *raisiné*. Mix in the cream and egg yolks and soak the bread in the mixture; drain and fry in hot butter until golden brown. Sprinkle at once with brown sugar. Prepare three figs per person on a slice of bread and pour on the *raisiné*. A little ground, caramelized almond goes particularly well with this dessert.

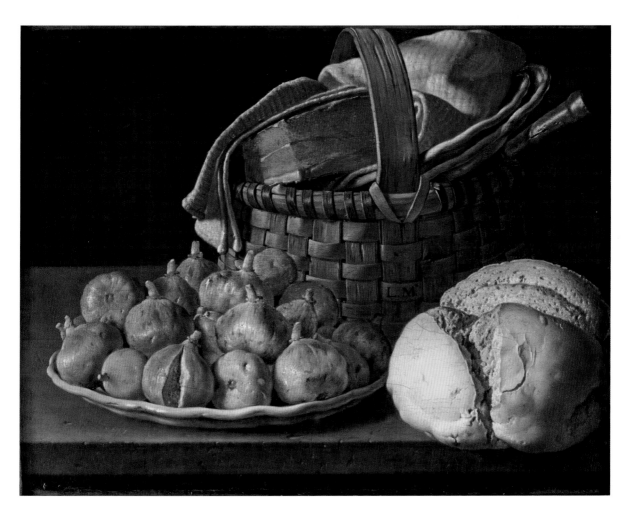

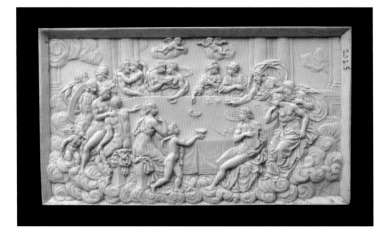

**GIOVANNI BATTISTA POZZO**
(c. 1670–1752)
*The Banquet of the Gods*,
seventeenth–eighteenth century
Ivory, 5 × 9 ¼ × 3 ¼ in. (13 × 23.6 × 8 cm)

What a wonderful piece! An ivory of glorious hue, finely carved. A steamy scene that the wholesome-looking protagonists do little to cool. Two young women, modestly sporting hats and clothes, turn away from the scene. But it's surely only a front, the better to enjoy in secret this parade of sensuality. Two further figures, both women perhaps, gaze into each other's eyes and share a cup in preparation for more carnal pleasures. One hand of an embracing couple leaves no room for ambiguity. Soldiers check the credentials of a newly arrived guest. Under the eye of a rascally angel, a couple is downing a potion. They will soon see if it has the desired effect.

The tablecloth is crisply folded. The revelers are comfortably ensconced on bundles of wool. The whole scene on this marvelous ivory plaque exudes well-being. One young woman is enraptured by the sound of the zither, another—wearing no more than she might—seems jealous of the bliss enjoyed by the cuddling couples. Her neighbors, interested solely in earthly food, have proven disappointing.

Faced by this spectacle, people who know their arts talk of intoxication; just like after excessive drinking. All these guests bear symbols shared by the pleasures of food and of the flesh. Two angels look on at the scene, giving their imprimatur to divine frolics that mix the delights of the table with those of the bedchamber. Centuries before it appeared, they seem to be acting out a quotation from Brillat-Savarin's famous *Physiology of Taste*: "The pleasures of the table can be relished by all ages, all conditions, all nations, and every day. They can be combined with all other pleasures and can be enjoyed in the end, and so console us for the loss of the others."

Among the many who have tried to marry these pleasures are Alexandre Dumas, Marcel Proust, painters such as Pierre Subleyras in his delicious *Falcon*, and Ingres with his *Turkish Bath*.

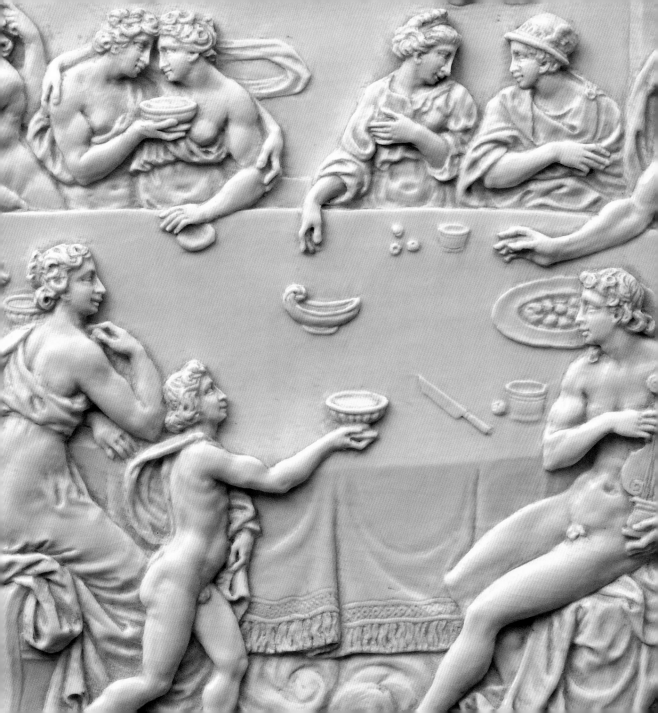

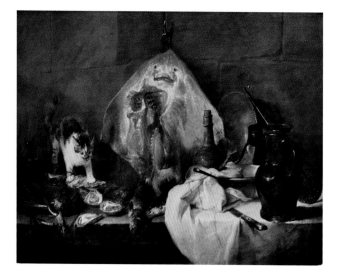

**JEAN-SIMÉON CHARDIN** (1699–1779)
*The Ray Fish* or *The Ray*, c. 1725–1726
Oil on canvas, 3 ft. 9 in. × 4 ft. 9 ½ in.
(1.14 × 1.46 m)

This still life summons up what was a formative experience in my life in the Louvre when the sidelong smile of this ray showed me how to enjoy the universal pleasures of painting. A slice of life, this canvas casts light on exactly how a meal is prepared. All the ingredients are accurately accounted for: even the fish is sea fresh—as confirmed by Monsieur Chardin's consummate talent. So let's go into the kitchen and check if it works.

**MONSIEUR CHARDIN'S RAY**
*2 ¼ lb. (1 kg) of fish for the stock*
*2 cups (50 cl) of white wine*
*Scallions (reserve a few for decoration)*
*A ray weighing approximately 3 lbs. (1.5 kg)*
*2 lemons, squeezed*
*Scant cup (20 cl) single cream*
*18 oysters*
*Oil*
*Cloves, saffron, peppercorns, salt*

Make a light stock with the fish and white wine, scallions (or onions), pepper, and salt, and cook for half an hour; colander strain and allow to cool.

Slice the ray into 8 oz. (250 g) sections. Plunge into the cool stock, season, and cook gently for 15 minutes. Remove the fish pieces, put to one side on a dish, and, having added the lemon juice, quickly reduce the cooking juices to obtain around a scant cup (20 cl) of liquid; add the same volume of cream, spice lightly with the cloves and saffron; reduce further to obtain a pleasantly saffron-scented, consistent sauce. Open the oysters and poach them in their water. Drain carefully and fry rapidly in boiling oil. Allow them to drain on paper. Cut some of the scallion stalks into 1 1/4-in. (3-cm) long sticks and pan fry. Lay out the sections of the ray on a dish or plate, pour on the sauce, add the fried oysters, and garnish with the scallion.

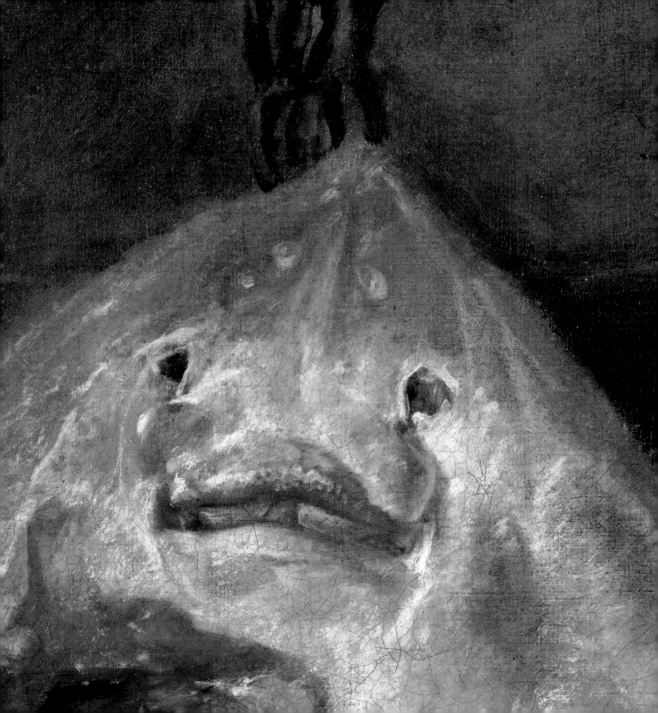

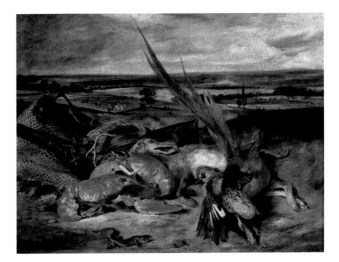

**EUGÈNE DELACROIX** (1798–1863)
*Still Life with Lobsters*, 1826–1827
Oil on canvas, 31 ½ × 41 ¾ in. (80 × 106 cm)

This is a picture without end. A slice of life frozen onto the canvas. No details, neither of time, nor place. A hunting trophy composed of pheasants, a hare, and … lobsters is an odd thing. The first two one might expect, but the presence of the crustacean is less commonplace. Perhaps the color of the shell after boiling caught the painter's interest.

By putting them all in one place, maybe the artist wanted to paint a panorama of life: land and sea, hunting and fishing, power and resignation? Or is he denouncing the absurdity of man, who is ever prepared to capitalize on Nature's bounty but is incapable of showing due gratitude for her gifts?

Meanwhile, the cook is impatient to grab hold of these trophies. He hesitates between the royal hare, the noble pheasant, and the sea air wafting in from the lobster. Might he not snaffle them all and profit from these little pleasures? That would make a very tasty conclusion to this delicious encounter, a feast of scented colors to partake of without stint.

Following suggestions from two artists who might have met—from M. Delacroix and his picture, from M. Escoffier (that emperor of cooks) and his culinary genius, I suggest you dig out the recipes for the menu mentioned below.

A "lobster thermidor" would make a nice entrée. "Salmi of pheasant with girolle mushrooms" would bring its own contingent of pleasure, and prepare our taste buds for the festival of aromas emanating from this famous "hare à la royale," while a light sorbet would serve as a fitting ending to this harmony of flavors. All these traditional recipes appear in the marvelous book by that famous chef who worked at the most prestigious tables of the early twentieth century: Escoffier's classic *Guide culinaire* (1903).

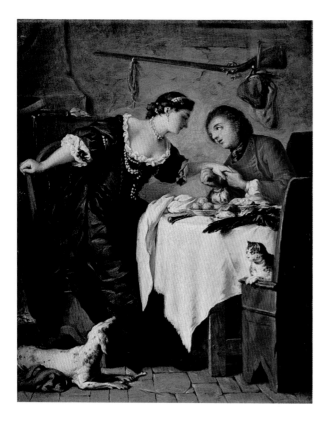

1. This scene is a disconcerting one for the eighteenth century: at that time, falconry was a long-standing tradition and killing such a bird would have been unthinkable. As a helpmate to its master and a redoubtable hunter, the bird was a protected species.

In fact this curious picture illustrates one of La Fontaine's *Contes* (Tales): Clitie has gone to beg Frédéric for his falcon to give to her sickly son; the lovelorn Frédéric has ruined himself on Clitie's account, however, and has just dispatched the bird, the last thing he owned, to make them a meal. Greatly touched, Clitie at last returns his love.

The dead bird here is still more at odds with an interior that is otherwise teeming with the signs and colors of life. As if in remorse, the game-bag in which the dead bird was taken has been thrown to the ground. But the meal…? The onions have to be peeled and the rabbit is still raw. Cooking all this will take a good while. Was the artist in too much of a hurry to paint his picture and forgot about cooking? But let us keep his secret. Seeing the beauty's sudden rush of affection, perhaps it would be better to avert our gaze; though, if I were invited to stay, I would transform this ordinary rabbit into a delicious meal, giving it plenty of time to cook—an ideal recipe for combining the pleasures of the table with the delights of love.

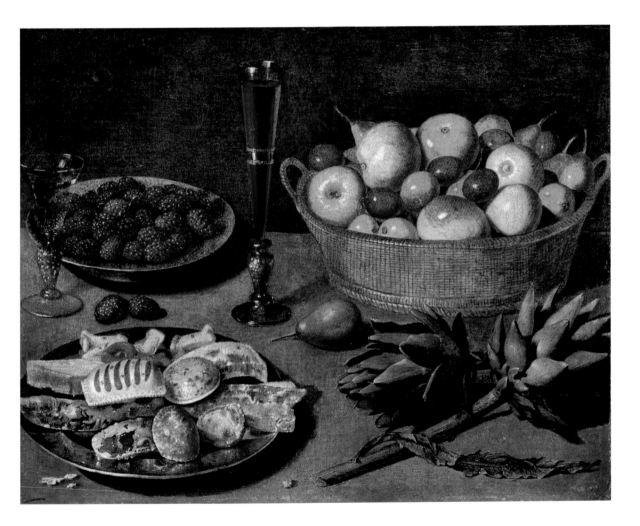

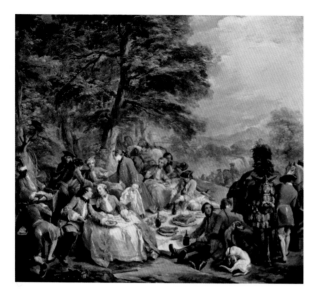

CHARLES-ANDRÉ,
*CALLED* CARLE, VAN LOO (1705–1765)
*Halt on the Chase*, 1737
Oil on canvas,
7 ft. 2 ½ in. × 8 ft. 2 ½ in. (2.2 × 2.5 m)

The history of hunting is inextricably linked with that of man, who, in his desire for food, has honed and refined it. Hunting with horses made it possible to pursue elusive, fleet-footed game and by the Middle Ages this form of hunting had become a privilege for princes and nobles. By this time there were two variants of hunting to hounds: *grande vénerie*, chasing large game (such as the stag), and *petite vénerie*, smaller game.

If in England hunting is regarded as a sport, in France it is a tradition. Under Francis I, it became a lifestyle for all the nobility. A hunt (those involved with or following the chase) is composed of horsemen accompanied by a pack by running hounds and men on foot (whippers-in in foxhunting) with bloodhounds, dogs with a very acute sense of smell.

A hunt has to be as scrupulously organized as any banquet. Each phase is announced by a specific descriptive call played by a bugler on his hunting horn. Events kick off in the morning with reveille and continue throughout the day, each episode being recognized and followed thanks to these calls: entering the forest, the animal is stalked, flushed out; the hunt's up and the *halloo* is sounded; once caught, the hounds get to work and the animal is dispatched. Then comes the moment the hounds have been waiting for. The animal is gralloched (disemboweled), other pieces may be cut off and a paw set aside for any lady present; and finally a share of the spoils is thrown to the dogs.

Hunting with hounds is often the butt of criticism, but it is the least destructive alternative, since one only animal is caught per meet. Moreover, no firearms are used, just a dagger—traditional, just like everything else in the history of the hunt.

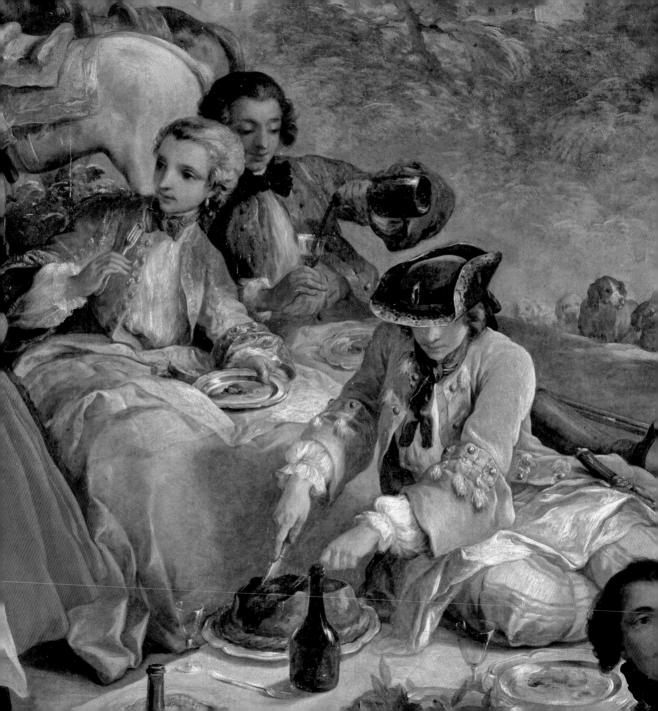

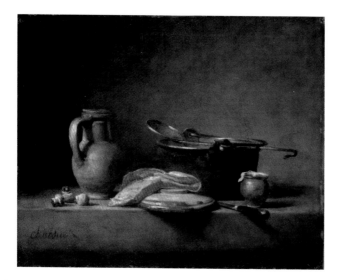

**JEAN-SIMÉON CHARDIN** (1699–1779)
*Still Life with Copper Cauldron,*
c. 1750–1760
Oil on canvas, 12 ½ × 15 ¾ in. (32 × 40 cm)

To examine a work by Chardin is always a rewarding experience. But is it due to admiration for his art or to love of food?

As in the famous *Ray Fish* above, one can sense a woman's hand at work in this picture. There too one might well select a side of salmon for a recipe one would love to prepare for dinner. However, in the Middle Ages, during a period of intensive consumption of fish—and not least of salmon—agricultural workers in the region around the Adour stipulated that they should never be served fish more than twice a week. The days of such easily borne excesses are long gone and, for many families, salmon is eaten only on high days and holy days.

**SALMON FILLET IN CREAM OF BUTTON MUSHROOMS**
*2 ½ lb. (900 g) salmon*
*2 oz. (60 g) shallots*
*2 lemons*
*2 ½ cups (150 g) button mushrooms*
*¼ bunch (10 g) flat parsley*
*¼ bunch (10 g) basil*
*3 tbsp. (40 g) butter*
*1 ½ cups (25 cl) white wine*
*½ cup (10 cl) fresh cream*
*Salt, powdered ginger*

Buy a salmon fillet prepared by the fishmonger. Cut into six. Finely chop the shallots, squeeze the lemons, wash and slice the mushrooms, cut the parsley and three leaves of basil with scissors. Liberally butter a hollow dish and lay in the shallots, herbs, and mushrooms. Place the pieces of salmon in it, add salt and a pinch of powdered ginger; pour on the lemon juice, white wine and douse the top with a little water. Cover with a sheet of greaseproof paper well rubbed with butter. Place in a hot oven for around 15 minutes. Then remove the fish onto a serving dish and keep warm. Put the cooking juices in a pan on the hob and reduce by half. Add the cream. Reduce a little further and pour the sauce over the salmon. Garnish with a sprig of basil.

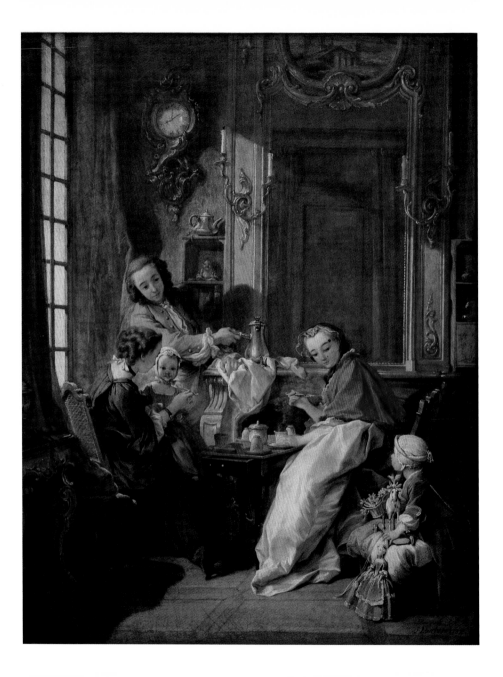

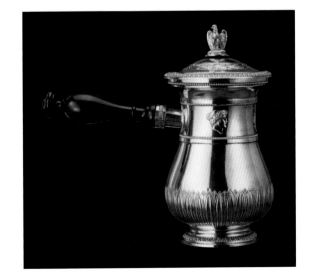

**1. FRANÇOIS BOUCHER** (1703–1770)
*The Lunch (*also known as *The Afternoon Meal)*, 1739
Oil on canvas, 31 ¾ × 25 ½ in. (81 × 65 cm)

**2. MARTIN-GUILLAUME BIENNAIS** (1764–1843)
Verseuse *decorated with the Arms of Napoleon,
King of Italy*, c. 1805
Silver gilt, 6 ½ × 7 in. (16.5 × 18 cm)

1. It's eight o'clock, or … very well ten, but in the seventeenth century lunches were copious and this snack can hardly be said to be that. Some specialists claim they can smell coffee; others contend they can taste chocolate instead. If, however, by this time people had mastered the latter, coffee was still a hit and miss affair and it was several decades before it really took off. Children were permitted chocolate, while coffee was an awkward infusion and the preserve of adults. A pouring vessel for chocolate should be provided with a *moussoir* for whipping, though, an essential accessory for making the drink successfully. The well-behaved child next to his mother seems curious to taste this new beverage, which comes as a surprise to the younger girl, more accustomed to chocolate. Be it coffee or chocolate, neither of these new-fangled drinks were associated with mealtimes but with collations, while their high cost meant they were confined to better-off families, like those in the house here.

**A BRIEF INTRODUCTION TO COFFEE.**
Originating in the Yemen, the coffee tree became widespread in Africa where the fruit was a favorite for a long time. Its history shadows its commercial significance. It is drunk and appreciated almost everywhere throughout the globe and its export is often the economic mainstay of the producer country. Grown in South America since the eighteenth century and imported into Europe and elsewhere with a panoply of different aromas, it is prepared according to host of recipes: in the Turkish fashion, in the French manner, as Italian espresso or cappuccino, not forgetting the celebrated Viennese coffee.

Its taste differs according to the variety of the plant. *Robusta*, high in caffeine, is vigorous and full-bodied in taste. *Arabica*, gently tonic and scented, is, depending on its source, subtler. But the nuances of this beverage lie in the manner in which it is prepared, and in knowing that tastes change from place to place, and even more from person to person.

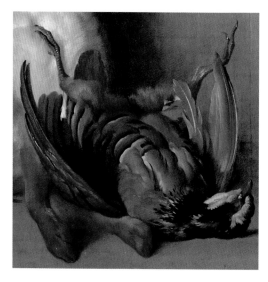

**PLAIN ROAST PHEASANT IN ITS OWN GRAVY AND FRICASSEE OF GREEN CABBAGE WITH APPLES**

*One plump pheasant*
*⅓ of a baguette*
*4 cloves of garlic*
*⅔ cup (150 g) butter*
*1 lb. (500 g) green cabbage*
*7 oz. (200 g) golden delicious apples*
*5 oz. (150 g) breast of lightly smoked pork*
*2 tbsp. (3 cl) Armagnac*
*Scant cup (20 cl) chicken or other poultry stock*
*Salt, freshly milled pepper*

**JEAN-BAPTISTE OUDRY** (1686–1755)
*Pheasant, hare, and red partridge,* 1753
Oil on canvas, 38 ¼ × 25 ¼ in. (97 × 64 cm)

This artist painted countless portraits and nature pictures, flower and fruit pieces, and he excelled in animals. This work shows three of them, but Oudry's preference for the pheasant is obvious.

Originally from Asia, in the West the pheasant was already known in early Antiquity. Greatly coveted as a gourmet food, the bird was considered noble and was welcome on the royal table. At great banquets in the Middle Ages, it was treated as a confidant, to the point where the knights and other guests who swore to defeat the Turks and retake Constantinople during the "Vow of the Pheasant" at the court of Philip the Good of Burgundy in 1454, were sure they would be betrayed by this trusty bird.

Choose a fine-looking pheasant (enough for 6); pluck and prepare; season the innards and stuff with the piece of baguette rubbed with garlic. Dab on one-third of the butter (3 tbsp./50 g) and oven cook for 45 minutes at 340°F (170°C). Keep basting while in the oven. Wash and leaf the cabbage; slice into slivers. Blanch in boiling water, drain, and dry. Peel and dice the apples into small cubes. Slice the pork breasts thinly and sauté in a further 3 tbsp./50 g of the butter. Put the cabbage in the same pan and cook for 7 minutes. Melt the final third (3 tbsp./50 g) of butter, and when very hot, add the apples. Toss them in the butter then mix with the cabbage

Remove the bird from the oven; deglaze the roasting pan with Armagnac; add the stock. Reduce for 10 minutes, carve the pheasant, lay the slices on a bed of cabbage and pour on the gravy.

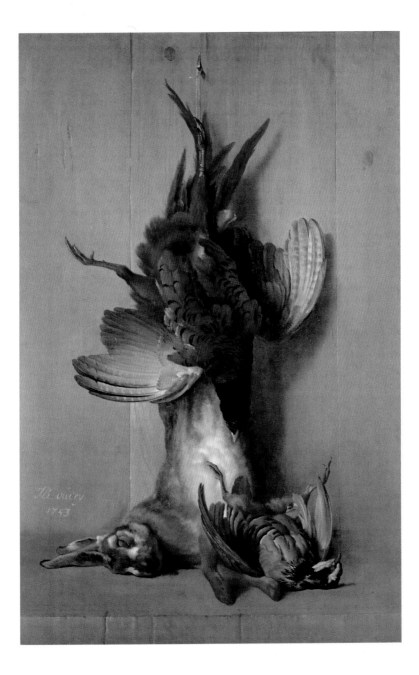

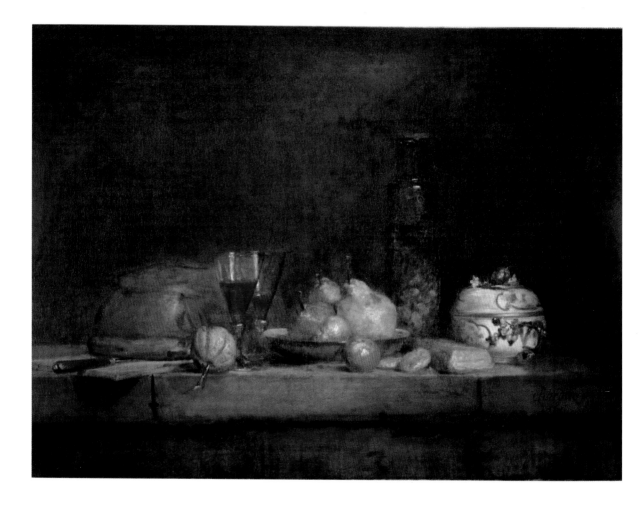

1. **JEAN-SIMÉON CHARDIN**
(1699–1779)
*The Bowl of Olives*, 1760
Oil on canvas, 28 × 38 ½ in. (71 × 98 cm)

2. **SÈVRES MANUFACTURE**
**Jacques-François Micaud**, *père* (1732/1735–1811);
**Jacques-François-Louis de Laroche**
(active at the Manufacture from 1758 to 1802);
**Henri-François Vincent, the Elder** (active 1753 to
1800); **Étienne-Henry Le Guay the Elder** (1721–1797)
*Olla and tray from the model for the service
"à frise riche en couleurs,"* 1784
Soft-paste porcelain

1. Chardin's canvases are full of smells so accurately portrayed that they vie with their models. This one is no exception to the rule, in spite of the chilly-looking meat pie standing forlorn on a common-or-garden wooden board. An unassuming knife waits to make inroads into the crust, while a citron exudes puffs of bitterness from its grainy peel. The acid scent of two apples of promising hue, one posing on a sandstone dish, the other on the table, mingle with the honeyed aroma of some well-ripened pears. The wiry bouquet of a robust wine of uncertain color and questionable origin rises up from a pretty stemmed glass.

On the left, we have a white earthenware pot with handles—very pretty, if too liberally strewn with plant life: flowers, leaves, and stalks. Next to the pot, a kind of flatbread or cake, insufficiently raised and too soon shaken from its mold, is totally overshadowed by a large bowl that contains the promised olives.

Spread out very simply in front of us, all these little colored dabs evoke invigorating smells: this pleasant snack offers itself up to the artist's palate in an act of delicious generosity. But, on further examination, the flower-bedecked white pot has a lid, itself surmounted by a diminutive green berry. And this fruit looks more like an olive than anything else. Perhaps the *Bowl of Olives* is a *Pot of Olives* instead. Maybe Monsieur Chardin was having fun throwing his many admirers off the scent.

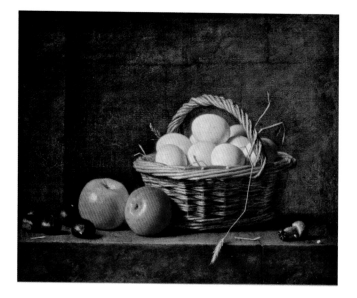

**HENRI-HORACE-ROLAND
DELAPORTE** (1724/1725–1793)
*The Basket of Eggs*, 1788
Oil on canvas, 15 × 19 in. (38 × 48 cm)

This autumnal picture presents a basket of eggs in the company of some sweet chestnuts, a fruit that once ensured the survival of a substantial section of humanity. An excellent animal feed, crystallized and elegantly sprinkled with sugar they can also charm the most delicate palates.

Apples are intensely symbolic. A globe-shaped fruit which, above and beyond its utility, has fueled more than one lapsarian quarrel. Allusion or metaphor, some are offered a fatal bite; others upset a whole cartful. The fruit features in nutritious dishes, sweets and desserts, drinks,

perfumed essences—and even in deodorants. No mere beautifying or health-giving ingredient, apples have cropped up in the media and even in politics. These here exude the dampish, sickly essence of their sappy juice. A denizen of a drier realm, an unassuming boletus mushroom, recently picked, gives vent to more woody emanations. A much-prized variety, it adds a note of class to the table.

But pride of place in this canvas goes to the eggs, and their white glow illumines the whole scene. Eggs have long been a welcome link in the food chain and their role has mirrored changes in beliefs and developments in science. More than a choice foodstuff, eggs symbolize life and represent the continuance of the species. Ensconced in their calcic shell, they play a starring role in cookery, and are prepared in myriad fashion: soft- or hard-boiled, poached, coddled, scrambled, in omelets, over-easy, and, less challengingly, fried.

Numberless memories waft up to me from this illustration, interwoven, but deliciously draped in scent and color. A recollection from yesterday or from yesteryear, of a meal rustled up by the woman I used to call "Granny." I was always overjoyed to take part in her family meals, all seated together around a savory or sweet omelet which Granny, and she alone, knew how to make.

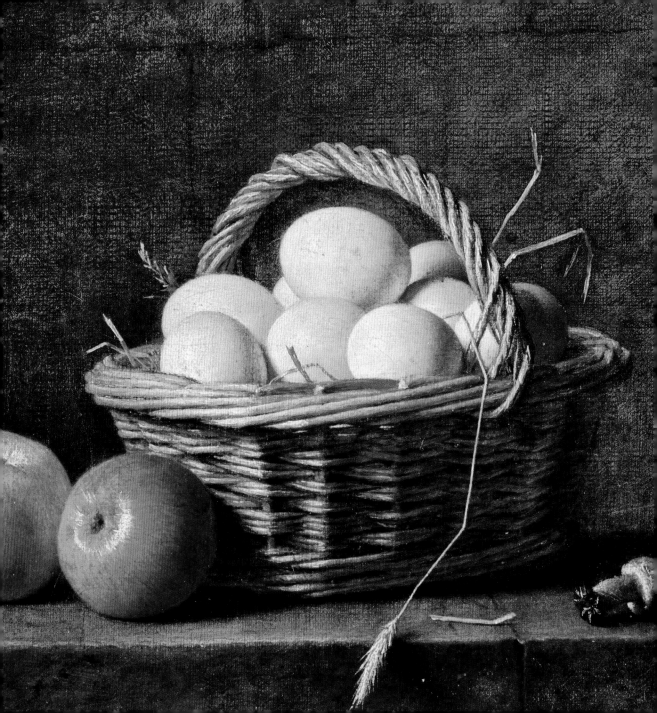

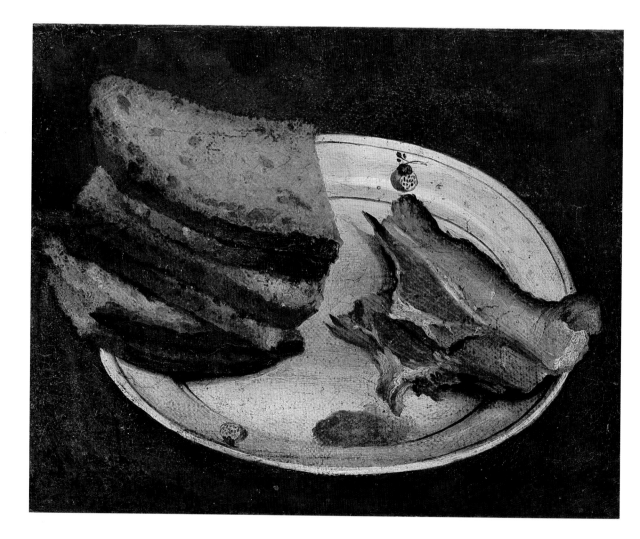

A piece of bacon from the flitch, trembling on a warm piece of bread, was one of the minor pleasures of eighteenth-century life. Indeed it still is today. The painter's truthful colors endow the picture with both taste and smell.

A truly spiritual foodstuff, pork finds a place in most cultures and plays a symbolic role. In Greek mythology, the pig is associated with Demeter, the goddess of fecundity and agriculture. It is also said that Zeus was fed on sow's milk. The animal's image among the Egyptians' was ambiguous, and he could be seen as malevolent: swineherds were strictly forbidden in temples. The negative reputation of the hog as a dirty and malefic animal reoccurs in Hebraic and Islamic civilizations, and Moses and Mahomet both prohibited their peoples from having any contact with the beast whatsoever.

Much appreciated in Antiquity by the Romans, Greeks, and Gauls, the pig was eaten by intellectuals and is cited by the Christians as a companion of St Anthony. From Homer and Aristophanes to Pliny and Cato, the animal crops up repeatedly in the writings of the Ancients. Pig-breeding is a simple affair and this made it the most widely consumed livestock in the Middle Ages. The fortifications architect Vauban saw it as providing effective defense against famine, observing that "this animal is easy to feed and anyone can breed one a year." A century later, thanks to the potato, French pig-breeders were the most dynamic in all Europe. Nothing goes to waste in a pig. It has survived the ages and inspired men in all four corners of the globe. The French gastronomic tradition, the envy of the world, is particularly associated with prepared meat products or *charcuterie*.

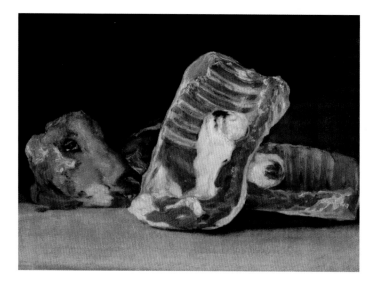

1. **FRANCISCO DE GOYA** (1746–1828)
*Still Life with Sheep's Head*,
c. 1808–1812
Oil on canvas, 17 ¾ × 24 ½ in.
(45 × 62 cm)

2. **NICOLAS HENRY JEAURAT DE
BERTRY** (1728–after 1796) (Facing page)
*Still Life with Mortar
and Sheep's Head*, n.d.
Oil on canvas, 30 × 23 ½ in.
(76 × 60 cm)

1. Imagine this picture, in a dark recess, reeking with congealed fat, exuding a damp odor—perfectly captured by the artist. The realism is astonishing. The one who prepared this animal must have been a cack-handed fellow, though, since at this time butchers showed pride in their work. Staring out blankly, the head seems to be waiting for something or for someone—for whom, I have no idea. The right-hand side has been sorely botched: the ear has been hacked off, braincase smashed. What you'd call a *shambles*.

The animal, resigned, with half a smile, bows to human law. The stronger dominates the weaker: a logical necessary for the survival of the species. But with what sin has this creature been impugned to have had such a punishment inflicted on it? Dressed and trimmed by a murderer, the loin-chops still hang on together, the tops of the ribs are all jagged, the neck has been hacked to bits. Catastrophe is in the air. One can be sure that the creature was mistreated in life and the meat inadequately stored. Only then, forgotten, stranded, did it catch the painter's eye. This is no sight for a gourmet, but an artist like Goya can converse at ease with the dubious tints of this stale hunk of meat. The flesh is drained of its natural purple and has taken on the off-putting glint of unprepossessing coagulation. The dried grease and the straggle of fillet confirm an advanced stage of deterioration. There is a glimmer of hope among this sorry autopsy: the fatty sacks alongside each contain a fine-looking kidney. These thick envelopes of grease allow them to reach the maturity all gastronomes appreciate. Finally some small pleasure to be had amidst this hatchet job.

On reflection, I wonder whether, in this rainbow-colored balancing act, the artist wasn't trying to combine sight and smell.

# LIST OF ILLUSTRATIONS

p. 22
**Frans Snyders** (1579–1657)
*Fishmongers at their Stalls*, c. 1616–1621
Oil on canvas, 6 ft. 10 ¾ × 11 ft. 2 ½ in.
(2.1 × 3.42 m)
Inv 1848
Department of Painting

p. 23
**Abraham van Beyeren**
(1620/1621–1690)
*Still Life with Carp*, c. 1646–1650
Oil on canvas, 28 ¾ × 24 in. (73 × 61 cm)
Inv. RF 1995-15
Department of Painting

p. 24–25
**Frans II Francken,** *known as* **Francken
the Younger** (1581–1642)
*Belshazzar's Feast*, seventeenth century
Oil on copper, 14 ¼ × 20 ½ in.
(36 × 52 cm)
Inv. MNR 582
Department of Painting

p. 26–27
**Pieter Claesz** (1597–1660)
*Still Life with Musical Instruments*, 1623
Oil on canvas, 27 ¼ × 48 in.
(69 × 122 cm)
Inv. RF 1939-11
Department of Painting

p. 28–29
**Louise Moillon** (1610–1696)
*The Fruit and Vegetable Seller*, 1630
Oil on wood, 3 ft. 11 ¼ in. × 5 ft. 5 in.
(1.2 × 1.65 m)
Inv. RF 1955-19
Department of Painting

p. 30
**Jacob Jordaens** (1593–1678)
*"The King Drinks,"* or *A Family Meal
on Twelfth Night*, c. 1638–1640
Oil on canvas, 4 ft. 11 ¾ in. × 6 ft. 8 ¼ in.
(1.52 × 2.04 m)
Inv. 1406
Department of Painting

p. 31
**Jan Steen** (1626–1679)
*A Merry Family Meal*, second half
of the seventeenth century
Oil on canvas, 32 ¼ × 26 ¾ in.
(82 × 68 cm)
Inv. MI 983
Department of Painting

p. 32–33
**Frans II Francken,** *known as* **Francken
the Younger** (1581–1642)
*The Five Senses*, first half
of the seventeenth century
Oil on wood, 22 × 33 ¾ (56 × 86 cm)
Inv. MNR 419
Department of Painting

p. 35
**Lubin Baugin** (1612–1663)
*The Dessert of Wafers*, c. 1630–1635
Oil on wood, 16 ¼ × 20 ½ in.
(41 × 52 cm)
Inv. RF 1954-23
Department of Painting

p. 36
**Abraham Bosse** (1602–1676)
*The Suite of Trades: the Pastry-Cook*,
c. 1635
Engraving and etching 10 ¼ × 13 in.
(26.2 × 33.2 cm)
Inv. 5193LR
Department of Graphic Art

p. 37
**Jean-Siméon Chardin** (1699–1779)
*The Brioche*, 1763
Oil on canvas, 18 ½ × 22 in. (47 × 56 cm)
Inv. MI 1038
Department of Painting

p. 38–39
**Willem Claesz Heda** (1594–1680)
*End of a Collation*, **also known
as** *A Dessert*, 1637
Oil on wood, 17 ¼ × 21 ½ in. (44 × 55 cm)
Inv. 1319
Department of Painting

p. 40–41
**Bartolomé Esteban Murillo**
(1618–1682)
*The Young Beggar* (also known as
*The Beggar Boy*), c. 1645–1650
Oil on canvas, 4 ft. 4 ¾ × 3 ft. 3 ¼ in.
(1.34 × 1 m)
Inv. 933
Department of Painting

p. 42–43
**Bartolomé Esteban Murillo**
(1618–1682)
*The Angels' Kitchen*, 1646
Oil on canvas,
5 ft. 10 ¾ in. × 14 ft. 9 ¼ in. (1.8 × 4.5 m)
Inv. MI 203
Department of Painting

p. 44–45
**Abraham Mignon** (1637–1679)
*Nest of Redstarts*, n.d.
Oil on canvas, 32 ¼ × 39 ¼ in.
(82 × 100 cm)
Inv. 1553
Department of Painting

p. 46
*After* **Willem Kalf** (1619–1693)
*Still Life with a china vase*, c. 1655–1665
Oil on canvas, 22 ¾ × 28 (58 x 71 cm)
Inv. RF 796
Department of Painting

p. 47
*Pair of lidded pots*, c. 1710–1725
Chinese porcelain with Imari decoration,
bronze mount, h. 11 × d. 9 in.
(28 × 23 cm); h. 12 × d. 10 in. (30 × 25 cm)
Inv. OA 11959, OA 11960
Department of Decorative Arts

p. 48
**John Russell** (1745–1806)
*Little Girl with Cherries*, 1780
Pastel, 23 ½ × 17 ¼ in. (60 x 44 cm)
Inv. MI 1113
Department of Graphic Arts

p. 49
**François Garnier** (1600–before 1658)
*Bowl of Strawberries and Basket
of Cherries*, n.d.
Oil on canvas, 20 × 25 ½ in. (51 × 65 cm)
Inv. MNR 36
Department of Painting

p. 50
**Abraham Brueghel** (1631–1697)
*Woman Taking some Fruit*, 1669
Oil on canvas,
4 ft. 3 ½ in. × 4 ft. 10 ½ in. (1.28 × 1.49 m)
Inv. RF 1949-4
Department of Painting

p. 51
**Luis Eugenio Meléndez** (1716–1780)
*Still Life with Figs*, n.d.
Oil on canvas, 14 ½ × 19 ¼ in. (37 x 49 cm)
Inv. RF 3849
Department of Painting

p. 52–53
**Giovanni Battista Pozzo**
(c. 1670–1752)
*The Banquet of the Gods*, n.d.
Ivory, 5 × 9 ¼ × 3 ¼ in. (13 x 23.6 × 8 cm)
Inv. CL 20815
Department of Decorative Arts

p. 54–55
**Jean-Siméon Chardin** (1699–1779)
*The Ray Fish* or *The Ray*, c. 1725–1726
Oil on canvas, 3 ft. 9 in. × 4 ft. 9 ½ in.
(1.14 x 1.46 m)
Inv. 3197
Department of Painting

p. 56–57
**Eugène Delacroix** (1798–1863)
*Still Life with Lobsters*, 1826–1827
Oil on canvas, 31 ½ × 41 ¾ in.
(80 × 106 cm)
Inv. RF 1661
Department of Painting

p. 58
**Pierre Subleyras** (1699–1749)
*The Falcon*, c. 1732–1735
Oil on canvas, 13 ¾ × 11 in. (35 × 28 cm)
Inv. 8010
Department of Painting

p. 59
**Pierre Subleyras** (1699–1749)
*Still Life with Fruit and Artichokes*, n.d.
Oil on canvas, 21 ½ × 27 ½ in.
(55 × 70 cm)
Inv. MNR 638
Department of Painting

p. 60–61
**Charles-André, *called* Carle,**
**Van Loo** (1705–1765)
*Halt on the Chase*, 1737
Oil on canvas, 7 ft. 2 ½ in. (2.2 × 2.5 m)
Inv. 6279
Department of Painting

p. 62–63
**Jean-Siméon Chardin** (1699–1779)
*Still Life with Copper Cauldron*,
c. 1750–1760
Oil on canvas, 12 ½ × 15 ¾ in. (32 × 40 cm)
Inv. MNR 716
Department of Painting

p. 64
**François Boucher** (1703–1770)
*The Lunch* (also known as
*The Afternoon Meal* ), 1739
Oil on canvas, 31 ¾ × 25 ½ in.
(81 × 65 cm)
Inv. RF 926
Department of Painting

p. 65
**Martin-Guillaume Biennais**
(1764–1843)
**Verseuse *decorated with the Arms***
***of Napoleon, King of Italy***, c. 1805
Silver gilt, 6 ½ × 7 in. (16.5 × 18 cm)
Inv. OA 10270
Department of Decorative Arts

p. 66–67
**Jean-Baptiste Oudry** (1686–1755)
*Pheasant, hare, and red partridge*, 1753
Oil on canvas, 38 ¼ × 25 ¼ in.
(97 × 64 cm)
Inv. MNR 116
Department of Painting

p. 68
**Jean-Siméon Chardin** (1699–1779)
*The Bowl of Olives*, 1760
Oil on canvas, 28 × 38 ½ in. (71 x 98 cm)
Inv. MI 1036
Department of Painting

p. 69
**Sèvres Manufacture**
**Jacques-François Micaud, *père***
(1732/1735–1811); **Jacques-François-Louis**
**de Laroche** (active at the Manufacture from
1758 to 1802); **Henri François Vincent, the**
**Elder** (active 1753 to 1800); **Étienne-Henry**
**Le Guay the Elder** (1721–1797)
*Olla and tray from the model for the*
*service "à frise riche en couleurs,"* 1784
Soft-paste porcelain
Inv. OA 11979 and OA 11980
Department of Decorative Arts

p. 70–71
**Henri-Horace-Roland Delaporte**
(1724/1725–1793)
*The Basket of Eggs*, 1788
Oil on canvas, 15 × 19 in. (38 x 48 cm)
Inv. RF 1982-78
Department of Painting

p. 72
**French School**
*Still Life with Bacon*, eighteenth century
Oil on canvas, 7 ¾ × 9 ¾ in. (20 x 25 cm)
Inv. RF 1998-9
Department of Painting

p. 74
**Francisco de Goya** (1746–1828)
*Still Life with Sheep's Head*, c. 1808–1812
Oil on canvas, 17 ¾ × 24 ½ in. (45 x 62 cm)
Inv. RF 1937-120
Department of Painting

p. 75
**Nicolas Henry Jeaurat de Bertry**
(1728–after 1796)
*Still Life with Mortar and Sheep's Head*,
n.d.
Oil on canvas, 30 × 23 ½ in. (76 x 60 cm)
Inv. RF 1998-8
Department of Painting

## PHOTOGRAPHIC CREDITS

## IN THE SAME SERIES